Leonardo's Ink Bottle

Leonardo's Ink Bottle

THE
ARTIST'S WAY
OF SEEING

ROBERTA WEIR

CELESTIALARTS

Berkeley, California

CELESTIAL ARTS PUBLISHING
P.O. Box 7123
Berkeley, California 94707

Celestial Arts titles are distributed in Canada by Publisher's Group West, in the United Kingdom and Europe by Airlift Books, in South Africa by Real Books, in Australia by Simon & Schuster Australia, in New Zealand by Tandem Press, and in Southeast Asia by Berkeley Books.

Cover phototgraphy by Larry Kunkel
Styled by Veronica Randall
Text design by Greene Design

The poem on page 205 is reprinted from *The Selected Poetry of Rainer Maria Rilke* by Rainer Maria Rilke, edited and translated by Stephen Mitchell. Copyright © 1982 by Stephen Mitchell. Reprinted by permission of Random House, Inc.

Printed in the United States

Library of Congress Cataloging in Publication Data:

1 2 3 4 5 6 7 / 04 03 02 01 99 98

This book is dedicated to

JEROME J. GARCIA

friend and fellow artist

CONTENTS

Part Two:
ART & MASTERY

Part Three:
ART & LIBERTY

Part One:

INSTINCT, INTUITION
& INSPIRATION

Art:

THE SEER AND THE SEEN

Seeing through the mundane and witnessing the sublime is
less than an eye-blink away. —Bodhidharma

Is an artist's vision different from the way most people see? The sensitive eye is the innocent eye, the way of seeing that has remained open to the freshness of view experienced by a child: free of preconceptions, unlimited by ideas of what is possible and what is impossible.

As we grow up this illumination is covered over by the dust of thought, obscured by conformity and confined by reason. Yet it is always available, if we can reconnect with the inner vision and invite the child who possesses it to live again in the light of the present moment.

What does every artist want? Every artist, every person, desires complete, unmediated access to the deepest self; a revelation of life that is one's own, that cannot be captured by objective thought, but which springs up from the "unique, particular, not-to-be-duplicated subjectivity of the individual which is the real source of human meanings" and the beginning of every art. (Edward Edinger, *Ego and Archetype*, Shambhala)

The artist's search for expression mirrors our human longing for wholeness and ecstasy. Coaxing form out of the formless we

touch the power that spins galaxies, that rests hidden in every tiny seed. To summon the vision we desire, we have to use our every resource—our mind and heart, our body and soul. We need to bind our reasoning mind to the inspiration of our first awakening.

We tend to regard thought and feeling as separate faculties, but in reality the mind is in the heart and the heart is in the mind. Great thoughts come from the heart; the mind feels and suffers. When we were very young we felt and acted out of this undivided self, but as we grew, our lives were conditioned and our thoughts and feelings became fragmented. Yet mind and heart are still facets of one subtly cut lens.

The light of life passes through the prism of an individual being to display a spectrum of qualities—the senses and their urgings, the mind an instrument of perception, analysis and invention, the soul with its grain of love and its endless yearnings. How do the different wavelengths converge to make one pure and transparent light?

We can try to respond to this question with thought; we will find many who have come to it before us and we can search out their wisdom as it has been offered to us—through philosophy and science, through religion and its practices. But we can also ask, can I, alone and on my own, obtain understanding and self-knowledge? Do we not have sealed up within us all that we need to guide us? We do! We have only to uncover our gifts and to follow them forward. Through devotion to truth and by mastering our art, whatever it may be, we begin to transcend our limited concepts of who we are.

Knowing one thing liberates everything.
—Tulku Urgyen Rinpoche

When the entire spectrum of physical, mental and spiritual qualities is suffused with feeling, the creative reveals a glimpse of its infinite picture. Through art, through intimately knowing one thing, energy earns a pattern, thought builds a structure, sensation finds a form and color. When strength of feeling overtakes the schemes of the mind to define and control experience, then we comprehend what to do; then action comes spontaneously and in astonishing ways. To release our creativity, we have to trust our feelings, our intuition, and let go of the safety net of the known. The known is everything that is not what we need this instant.

To bring the unknown, the subtle, the inward out into the sensual world, many visions may be born, live and die one after another before the true work of art arrives, be it a painting or a partita, that did not exist before this one never-to-be-repeated moment; a work forever immediate, timelessly new.

Reason has never guided us in this movement. Because we are conditioned to be rational, our emotions suppressed, one of the greatest values art has for us in our time is in striking and releasing deep feeling. For this the artist needs no mediator or interpreter. Intuition directs thought. Our intuition tells us when we are approaching the mark, and when we are off. Our instinct guides the direction of our effort to realize a feeling. And to hear the ringing bell of intuition we need to cultivate emotional honesty:

Honesty is clarity—the clear perception of things as they are. Perception is attention. That very attention throws light, with all its energy, on that which is being observed. This

5

light of perception brings about a transformation...
—J. Krishnamurti

Who is transformed—the seer or the seen? Mysteriously, the transformation is in the act of perceiving itself. A child's attention is absolute; that is how the child is transformed day after day. The light of unbiased perception reveals the deep meaning of objects, allowing us to gain direct knowledge of the world, both our inner and outer existence.

To know more, we look for a way to dissolve the preconceptions that cloud our vision. To learn to see clearly, drawing from life and nature is a supremely direct practice, and though it has countless techniques it is blessedly free of theory; we are simply observing to discover form. This undistracted attention can be the thread that leads out of the labyrinth; the one thing that liberates everything. In our art we are each a unique awakening consciousness at work, and also its first witness. We succeed and we fail. It is not a mountain we climb, but a long journey over hills and valleys.

Do we need safety—safety to feel, to return to ourselves, to create? Our life is brief and dangerous. We can't wait for safety; there really is none except within ourselves, the sanctuary from which we can look out upon the world interestedly despite the inevitable. We have the safety of knowing that although we are that which has a beginning and an end, we are also that which is beyond time, which is the essence of innocence; that is, unobstructed, open awareness.

What am I feeling now? What is my deepest desire? That feeling, that desire is the birthplace of my next work. I need for

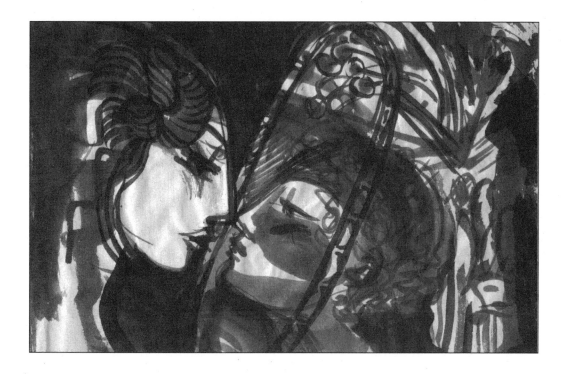

some reason to manifest my feeling; I yearn to make it visible. To go as far as possible in realizing my vision, I must be willing to recognize, work with, and expose my hopes and fears, my dreams and my sorrows. However deeply I pursue myself, that is exactly how far another person can enter into my work.

We need skill in order to discover as well as to express. Skill opens many doors for the artist. We know it is not an end in itself, but mastery is half the means, even though an absolute master wastes no time on technique and has discarded skill as a criterion.

Knowledge is the trap. When you have caught the fish you can throw away the trap.
—Hazrat Khan

How we arrive at command of our powers in an art is a measure of the scope and sincerity, the innocence and purity of our perception, our intelligence and our courage.

Think back to a time when you were moved by the work of an artist, a musician or a writer. That voice spoke intimately to you; that artist's work is a living thing that has a relationship with you. When we recognize and receive great artists, the beauty and strength of their expression flows into us and instructs us. With devotion to our original, essential way of seeing, we too can master the art.

Paradise:
THE INNOCENT EYE

A child does not know that the fire burns, the child only knows that the fire is beautiful...Every moment of its life it lives in a complete vision of beauty...In childhood the consciousness is in paradise. The child living in the same world of woe, treachery and wickedness as the grown-up is happy because it is not yet awakened to the other aspect of life. It only knows the better side of it, the beauty of life. And therefore that same world is the Garden of Eden for the child till it grows and is exiled from the Garden. —Hazrat Khan

A child's vision invests everything around it with the radiance of its own freshness and clarity. This luminosity unveiled through art can be so uplifting that we are transformed, our life brought whole into the present. What does it mean to live in the moment? It means we are open to our feelings, thoughts and instincts continuously, so that who we really are may truly live. Am I here? I am here. **I am that child.**

The bliss of nature, the enchantment of love, the poetry of dreams; the spirit voice whispering in our ear calls us back to our spotless original nature whose inspiration is the fundamental fact of our lives, though we are generally unaware of it, just as we are unaware of the orchestrated functioning of our body; the complex, clustered processes working together moment by moment to maintain this individual entity. What could possibly drive this complicated machine other than the obsession of life for life? This obsession for experience and knowledge is the elusive inspiration, our very source and true being. To know it intimately, to be immersed in it as a fish is alive in the sea is the attainment we desire. Every artist searches out a way. We are born with distinctly developed gifts, but without inspiration there is no joy in our life, there is no life in our art.

When visionary perception and technical mastery meet in a work of art, it comes alive with a vibration and a music, sweet or harsh, that resonates in all who encounter it. This new life with its humbling grace is the artist's liberation.

> *A man's work is nothing but the slow trek to discover, through detours of art, those two or three great and simple images in whose presence his heart first opened.*
> —Albert Camus

All the experiences, the great and simple images we gathered in childhood, are still living, moving through lives we know nothing about. These images are the key to reawakening the openhearted way of seeing we enjoyed before we were conditioned away from our natural selves. The lives we know nothing about are our own. We can recover and reclaim our germinal experiences and possess them in this moment. We can restore the wholeness of vision we were born with. All we need is a way back. We can relax our inhibitions and allow ourselves to clearly remember the flashes of sudden acquaintance with life and death, the leap of joy or the sinking into sorrow, the shock of beauty and the whip of fear which we encountered in the purity of our first sight.

We possessed this purity without aspiring to it; it was a natural quality of our being. **Nothing has changed.** All that keeps us from knowing our true nature are the beliefs we have acquired in life. We have had to give up our innocence in order to live, and now we have to get it back if we are to live fully. But I think it is not so difficult. All that stands between us and our undivided self is the accumulation of thought. To cut through the sludge of time we can take the easy way: simple remembrance.

When you think of yourself as a child, do you think of the times you spent with other people or of the private perceptions that your consciousness apprehended and that, perhaps, still dominate your obsessions? As children we have all had moments when something profoundly altered us in the midst of people who had no idea that anything was happening, or we were alone with our thoughts in a room or a field or a sand

dune; we saw something—a lizard, a dragonfly. Even if a child is never left alone, it plays alone in its thoughts and fantasies, absorbed in a world no one else sees.

Once I had a beautiful glass marble. I used to face the light and hold that marble right up to my eyelashes, turning it slowly until needles of light broke through the jelly of glass, the little globe I thought of as a miniature ocean. Only one marble could perform such a display, and one day I lost it, and though I looked through countless glass marbles after that I never saw another like it. The child floats freely into the infinite space of the glass, until one day the magical glass is gone; it is not in the box, it is not anywhere because it is the child who has disappeared.

MAPPING A MOMENT OF WONDER

The Year of the Night of Stars, 1945. My family lived in a large apartment building with other young couples and children—most of the men just home from World War II. In the humid summer air of a Chicago evening, neighbors lingered late in the courtyard. It must have been a particularly hot night, because I was kept outside long after dark, drowsing in my young father's arms, and as the grownups talked and laughed, I idly followed the path of a firefly upward into the sky.

What I saw had surely never been seen before. The sky was utterly black, and over the never-seen blackness, clouds of light-dust sparkled with colored jewels and glittering pinpoints every-where. All above us was an immense shimmering web of light; no inch of sky was empty of stars. I began excitedly pointing and shouting "Look! Look! The sky! The sky!" But nobody looked;

the people went on talking. "Look! Look!" I insisted, until finally someone said, without looking up, "Alright already, I see, I see, the stars, I see!"

Abashed by the indifference of the grownups, I contented myself with looking quietly, alone in it; and as I continued to gaze into the sky I began to sense that it was seeing me too. Something enormous was watching me, closer than the people, closer than my daddy's arms. Something that knew me was lifting me up.

A child has no sense of time, and so the child can perceive timelessness:

> The corn was orient and immortal wheat, which never should be reaped, nor was ever sown. I thought it had stood from everlasting to everlasting. The dust and stones of the street were as precious as gold...Boys and girls tumbling in the street, and playing were moving jewels. I knew not that they were born or should die...Eternity was manifest in the light of the day, and something infinite behind everything appeared: which talked with my expectation and moved my desire...and all world was mine...
> —Thomas Traherne

To recover this incandescent vision and allow nature to operate through us, we need to cultivate receptiveness as a balance to the active, achievement-oriented bias of our conditioning. Just as it is a release and a pleasure to stand outdoors in nature and to feel the sense of space, it is the same when releasing into our inner nature; not a struggle but a relaxation of tension, expansion into a larger sphere—the vast sphere of a feeling consciousness; inner space, limitless inner space. And to enter this space, there is nothing we need to do—exactly nothing. In the

process of reawakening childhood's angle of vision there is nothing to do, nothing to create, nothing to perform. All the work is inside in our mind and heart. Doing nothing is the way in, if only we remember ourselves, and we can still touch the child of our memory because that child is our real self. The adults we have become are a bit like growths that have extended beyond their natural life, the life that shaped us and which we have left behind in time. But is anything ever really lost? The exact nature of time and space is not known; what if it's the same Spring and Fall every year? What if

it's the same

sky the same

dragonfly

the same

eye

Webster's dictionary defines memory as "the mental capacity or faculty of retaining and reviving impressions." Yet memory is not only mental, but sensual, intuitive and emotional as well. It is possible to revisit our past and to feel as strongly in the memory as we did at the time of the event. Once aroused, feelings have continued to build in our body, mind and heart beyond the time the impression was made. Lifelong obsessions are born and a world view established in the earliest experiences and their propagation in the total memory, whether a person is aware of it or not.

To remember more and more subtly, more and more vividly, moments and scenes from your early life, draw from these memories and write them down as an ongoing discontinuous

autobiography. It isn't necessary to track the chronology but to look for the feelings and spontaneous perceptions that have been blunted in growing up. Drifting back in time we often recognize images that have repeatedly sprung into our minds because of associations in the present, and which we have quickly dismissed. But I am saying, dwell on these images and you will begin to have deep dreams. Hold these early impressions before you. Accept with gratitude the tears they may bring. Revelations flow in the young and there is no end of visions that follow each other once the door of remembrance has been opened. The deepest realizations of life take place in passing, but we can have them always if we acknowledge them and regain our open heart. **Opening is not forcing, but allowing ourselves to feel.** Deep feeling is the essence of every art. If we can stop defending for a moment we are safe with the power that is closer to us than we can know—the creative power that is operating through us. Like the pupil of the eye this naked

self is an open space that sees all but cannot see itself. To see itself it must find a way, and **YOU ARE THE WAY.** Love the child you were and from whom you have long been separated.

We put away childish dreams and desires and bit by bit we grow away from ourselves. There are so many schools of thought about how to go back to the garden, but we are already there. That is, we don't have to gain anything, we just have to drop the burden of thought that obstructs us from seeing ourselves and being ourselves in the world. Once we have stolen some time for self-immersion, we can let our memory roam through its rich store. Now we are there, in that little courtyard or playroom; we see and feel as we did then, we are now who we were. Going deeply, we recognize our early life as our authentic life and we can honor our unspoiled self by learning to see clearly in the present. Throw out your old beliefs; let the world look strange and new. Draw it, sing it, write it to know it, to grasp and hold it. Before we were told that anything was wrong, everything was right. That blossoming plum tree is as glorious now as it was then. Paint it from your heart, the same heart that received it with wonder so many years ago.

Any vivid detail of a memory is a key that unlocks the door to sensation. With the sensual vibration the past and the present meet and resonate together in our heart. It is at this point that we have recovered the vision. When we permit ourselves to have our original feelings, the emotional capacity of our present life is reflexively deepened, and it is the expression of this profound feeling that distinguishes art from other endeavors. We want to know the heart of the world.

Man has received from heaven a nature innately good, to guide him in all his movements. By devotion to this divine spirit within himself, he attains an unsullied innocence that leads him to do right with instinctive sureness and without any ulterior thought of reward and personal advantage.
—I Ching

Pathways
EXCAVATING CHILDHOOD

- What were the first works of art that you were exposed to and which moved, attracted and excited your interest as a child? They may have come to you as cartoons, book covers, trading cards and magazine photographs, songs echoing in the mind, poems held in the memory by a line or two, a pottery cereal bowl, flowers on a glazed plate, a crystal vase catching the light, even a painting in a museum. Can you gather some of these relics together in a drawing or as prints or photographs?

- Can you use these pictures as sources or subjects for your own work?

- Drifting back without any sense of urgency, can you recall what poems and pictures puzzled you and made you wonder about their meaning?

- Are any of them works you came to know later?

- Mentally walk through the first home you remember. What images appear?

- If you now move more slowly, what details come forward that you had overlooked or forgotten?

- Do you remember how you represented the sun and moon?

- A house or dog, a tree, a flower?

- Where did you like to draw? At the kitchen table, or on the floor of your room?

- What were your favorite colors, songs, games?

- What were the dominant subjects of your drawings and fantasies?

- Are any of these subjects in your work now? Could they be?

- Did you fall in love as a child? With whom?

- What was your first experience of school? Who were your kindergarten and first grade teachers?

- Did a teacher befriend or encourage you? What do you want to tell them?

- What precious or secret thing did you carry in your pocket or keep under your pillow? How did you get it?

- What made it special?

- What story or fairy tale affected you? How has its meaning stayed with you?

- Can you now interpret its symbols in relation to your life?

- What in nature elevated or alarmed you? Thunderstorms, the ocean, great heights, animals, snakes, birds? (I feared that I would float out of my house through an open window and be unable to find my way back home. Voices were calling from out there.) What did you imagine seeing or hearing in the dark of night?

- Did you have a beloved pet?

- What was its name and what happened to it?

- While looking at a photograph of yourself at four or five, ask, what did you lose that you could not regain?

- What did you gain that you can never lose?

Beauty:
THE ETERNAL COMPASS

To any artist worthy of the name, all in nature is beautiful,
because his eyes, fearlessly accepting all exterior truth,
read there, as in an open book, all the inner truth.
—Auguste Rodin

Who has not fallen under the spell of beauty, perceiving in this immense universe some person or object or place to love, to be enthralled by? Beauty in the world awakens the sense of beauty in our hearts.

What is so glorious as the privilege that man enjoys of being alive, and being able to see and discover beauty all round him!...that is what we artists are here for...to reveal beauty. This studio is my garden; here I am alone, and happy. Today, outside in the city, all is confusion and distress, the black wings of war are hovering... —Constantin Brancusi

Beauty is not mere grace of form or a canon of measurable proportions or symmetries. The sense of beauty lives in the heart, which finds happiness in its expression, and it lives in the intellect as the idea of perfect knowledge. Beauty is an attribute of our inner being that discovers itself in the mirror of the world. If beauty were not a part of our being, we could not respond to it and vibrate with it. The thunderheads against a

cobalt sky, lovers' eyes gazing into one another's, the white bird as it rises, the colors of sunrise, the face of the moon, the opening flower and its sweetness, the dying flower and its sadness are all a dim reflection of the beauty we come from and which our soul remembers.

At its greatest extremes, the experience of beauty has the capacity to transform our lives. When we are young we see the beautiful beings around us in their eternal aspect, without self-consciousness. We see the beauty and the grace of the other children and the godliness of the older boys and girls.

The quality of beauty cannot be analyzed. The art-critical definition of beauty as a sentimental outmoded value of art demonstrates why the critic is a critic and not an artist. The peacock's train is the result of erotic competition, but can anyone really explain why the female surrenders to the extravagant display of the male? Or why the bowerbird decorates its mating chamber with colored stones and flowers, except that the love of beauty is an instinct?

> *Love seeks to procreate in beauty and to give birth to the beautiful.* —Plato

Surrender to beauty and put away cynical sophistication. For the artist, the effect of beauty is a rapture which effaces time. It is rightness with all in its place, the affirmation of perfection, and perfection itself; the lost chord.

> *Divine beauty is at the same time: more-than-luminous darkness; dazzling plenitude of being; boundless void, pure receptive power; immeasurable grace, the rigorous measure of all things; love and peace, uniting everything with every-*

*thing; life, joy and freedom; the disappearance of all bound-
aries in the infinite; the act of redemption; majesty.*
—Leo Schaya

Despite the trivialization of our deepest yearnings and ideals in present society, the artist remains faithful to his instincts and trusts his vision. Hidden within the beauty of the poem is the poet; behind the painting is the painter. There is no pure quali-ty—no intellect, no wisdom, no beauty at all—without the one who is the source of it and to whom it belongs. That one is you!

And yet, as Christmas Humphreys has written, "In the pure contemplation of great beauty there is no sense of self, and com-pletely to be free of self is a moment of enlightenment." To experience this moment of enlightenment, all we need is to rest in the enjoyment of beauty, taking time to remain in the moment, staying in connection with the object of our attention.

Think back to your first innocent awareness of beauty. It may have been your mother's face, the wings of a butterfly you tried to touch, a brightly colored stone, a rainbow. Allow your-self to revive that vision without attempting to capture it in thought. Direct your mind's incessant need for material to the simple in and out of your breathing, while holding the beautiful image before you as long as you can. There are no obligations, no work more rewarding than this, other than expressing this beauty through your art.

Pathways
RELEASING BEAUTY

- Can you recall your first conscious experience of beauty?

- How old were you and what did you see or hear, feel or touch?

- Was it a part of your daily life seen through your awakening perceptions, or some unusual or rare occurrence or object?

- Can you draw or describe the beautiful object or moment? Take time with this rumination—there is no need to hurry. Let the image form in your mind over time, asking your memory for every detail, using all your senses.

- Are you beautiful? Say "yes" to this question and say it again and again to the mirror, to your heart and hands, to your whole life. Linger on the facets and details of your inner and outer beauty, find a way to represent the feeling of your particular beauty, this exquisite body which is yours, that can touch, taste, hear, see, smell, and which, unlike the rocks and trees, is free to move through the world. Remember your body is beautiful for its life and powers, not merely for how it looks.

- Do you have a special place of beauty you like to go to?

- Can you go there, literally or in your imagination?

- Can you represent or evoke it in words or sounds or images?

- What is the most beautiful painting, song, poem, music or object in your immediate environment? What landscape, tree, flower, face, object or animal can you see or touch right now?

- Can you take time to touch or to gaze at this object while feeling the sensation of your breathing?

- Allow yourself to feel the sensations of pleasure regarding an object of beauty.

- Stay with the beauty as long as you feel it, then let it go.

Desire:
THE DIVINING ROD
OF TRUTH

*I have found that things unknown have a secret influence
upon the soul: and like the center of the earth unseen, violently
attract it....There are invisible ways of conveyance, by which
some great thing doth touch our souls...Do you not feel your-
self drawn with the expectation and desire of some great thing?*
—Thomas Traherne

The instinctive desires of people become overwhelmed by the pressure and confinement of daily life in a society dominated by materialism. Very few are happy in their work, and by the time they are free to pursue a dream, they may have lost the energy that fueled the desire!

> *And if there is anyone who has no wish, he should not stay
> in the world, he should avoid the crowd as he cannot exist
> there; he should go into the mountains, and even there he
> should turn into a tree or a rock in order to exist, because to
> be a living being without a wish is not possible.*
> —Hazrat Khan

Before we can fulfill a desire, we have to know what it is that we desire. In the course of a day, we desire many things, and these desires may seem trivial or they may seem pivotal, but

they tend to come and go in response to various stimuli; and they may contradict each other and even cancel each other out. The first requirement for realizing a desire is to recognize it, to enthrone it, to acknowledge that our desire is a flame burning at the core of our soul that cannot be denied. This is devotion itself, because we are taught to repress our desires as if they were a danger to the life we know. They are.

So the desire is the beginning of every accomplishment. Only a powerful and continuous desire leads us through all the difficulties into the freedom and independence of spirit we need to reach the goal. Any endeavor of value at some point may feel unattainable, yet when there is a strong desire, the will to realize it can support a person through the most impassable circumstances. The greater the desire, the more indomitable the will. Desire turns a wish into a destiny.

We are drawn to art as a way into truth and a balm to suffering. We are drawn to art as a revelation of our inner music. We are drawn to art by its power to confront and master the limitations of our life. We are drawn to art that we may soar with it above the prison of thought. We are drawn to art for the pleasure of it!

In art the stifled unconscious leaps up like a wild animal to meet its manifestations. The artist who desires the energy of that animal learns to mount it and ride it. But as well as emotional expression, art is also a philosophical journey on which each artist carries a unique map to the destination, and the contours of that map are engraved on the heart.

You can do anything you want to do. What is rare is this actual wanting to do a specific thing: wanting it so much

that you are practically blind to all other things, that nothing else will satisfy you. When you, body and soul, wish to make a certain expression and cannot be distracted from this one desire, then you will be able to make a great use of whatever technical knowledge you have. You will have clairvoyance, you will see the uses of the technique you already have, and you will invent more.
—Robert Henri

Every artist's journey begins in the heart. The desire is a magnet; a divining rod that draws the will through time toward its object. Only what a person is deeply interested in determines the irreversible direction of their inner movement. The natural desires of life—for relationship, experience and exploration, for art and ecstasy—can become numbed by time and creative confinement imposed by a society that stimulates and exploits our most primitive fears; but since the universe itself is in accord with our desires, to give them up brings only frustration and unhappiness.

In our art we may experience the desire to destroy as well as to create. When we feel conflicting desires, we can follow them through at the same time in our work by allowing opposing feelings to move through us without resistance. Whether on paper or canvas, as in every aspect of life, we must keep moving to reveal the fate we are born to fulfill.

He begins to die that quits his desires.
—George Herbert

How do we recognize our deepest desire, our most abiding interest? How do we choose among the possibilities in life that attract us? Desire springs from our hearts but to manifest

it we need to make the conscious choice to recognize the desire, to claim it and to dedicate ourselves to its attainment. Acknowledging our fundamental interest and reaffirming it each moment and in every act of every day is the way to completion. Holding the desire in the conscious mind strengthens the will to realize it.

How will we find, identify and flow with our deepest desire? This is so easy! Pleasure is the stimulus for desire. Pleasure, what an infinite concept!

Whatever is the greatest pleasure life has given us is what we desire to capture for ourselves. How and where we have found transcendent pleasure in the past determines the shape of our desire. What we really desire is never an object but a feeling. Our nature will seek to obtain this feeling *through* an object we feel attracted to.

This movement begins in earliest infancy. In the child's kingdom there is a sovereignty of self, an immediacy of satisfaction. The child's needs and desires are clear and immanent. In its helplessness is its domination over its world. But as we grow, our crown begins to slip; frustration piles on frustration and we have to fight our way through a life that demands that we disregard our innate, innocent sensibilities. All our lives we yearn for peace, harmony and love, yet we are kept from our goal, which requires surrender, by the pressing need to conquer—to conquer others, to conquer the world. The little king must put on the sword and buckler. Yet in actuality it is only ourselves we have to fight. We have to defeat the little emperor inside us who by now is full of purposes, habits and beliefs, and who has taken on a manufactured identity and manufactured desires in order

to pass through the world without betraying vulnerability. If we are hurt we have the tendency to hide it, because in the natural world the injured animal will be set upon and killed. By the time we are socialized into adolescence, we have become a pastiche of adopted behaviors, concepts and goals, and these accretions bind themselves to us as tightly as barnacles on a whale. Yet even this sad state of affairs can lead us forward, for once we find ourselves in this condition, we begin to feel a new desire, a desire for freedom. We don't know what it will look like, but we now know what it is not.

This freedom exists in an entirely different context than the life we experience outwardly. Once we feel that spacious inner universe, we will want to return to it because this is where our true desires dwell. Turning away from the outward disappointments of life, we begin to sense and to see the beauteous world we were born to inhabit. In the end, our great desire is to follow our original instincts, which lead us broadly and deeply and, ironically, out of desire. Art is a gift that takes us closer to our origins and to our destiny.

Pathways

HEART'S DESIRE

- Do you find it is acceptable, morally and spiritually, to experience desire and to receive the objects of your desires?

- Or do you believe that desire should be renounced in favor of a spiritual direction that transcends it?

- Can you accept that before we can transcend desire we need to first have the experience of fulfilling it?

- Do you have a desire that has been a lifelong yearning?

- Can you distinguish this inborn desire, such as the yearning for self-expression through love, music, art or knowledge, from transitory conditioned desires such as approval, wealth, fame, property?

- Do you remember that these conditioned objects have been grafted onto our awareness and do not really belong to our original nature?

- When you desired an object or experience that you received how did you feel in the moment that your wish was fulfilled?

- Have you ever felt satisfied?

- If so, take some time now to savor that feeling. Can you describe it in words or pictures or music?

- If you have never been satisfied, what desires have you repressed?

- What prevented you from expressing a wish, from reaching out to claim it?

- Can you claim it now?

- What is your inmost desire that has not yet been met?

- Do you ever experience your heart's desire in your dreams?

- How has it worked its way into your art? What can you do to realize it?

- For one day keep a log of all the desires, great and insignificant, that enter your conscious mind. Can you trace the origins of any of these desires to the various stimuli of your daily life?

- Review your list and arrange the desire objects hierarchically, from the superficial satisfactions to the deepest call of your soul.

- Do you think it possible that you obtained life in a human body as the result of desiring it?

- Frame a modest desire in your mind and immediately fulfill it, so you can experience the sense of peace that comes from a desire satisfied.

- Can you give yourself something today that was denied you when you were a child?

- Confess to a friend a hidden desire and make an image of it that anyone can see.

- Imagine you are walking down a corridor at the end of which is a door. As you approach the door, you know that something wonderful is behind it, waiting for you. Allow yourself to feel the expectation of happiness and peace. Slowly walk toward the door until you touch the doorknob. You open the door and...what do you see?

- If you do this visualization often, you will discover recurring themes that can guide you closer to yourself and your true dreams.

- Using these suggestions, find the desire that is calling you as a flame calls to a moth. Allow yourself to fly to it, to let down resistance and the fear of loss, and by letting go, obtain in the mind the desired object.

CHAPTER 5

Creativity:
THE OUTER EXPRESSION
OF INNER WORLDS

Not this, not that —Upanishads

Why is there something rather than nothing? Why? Because you wanted it! Once you felt a desire, you stepped onto the treadmill of experience. Somewhere, perhaps, there is nothing. But in that nothing there is nothing to know its nothingness, so in a sense nothing cannot exist; if it did, it would be something!

To witness the creative, look in the mirror. Once we are satisfied that we exist, why should we not manifest what we desire? We are like the great creative force in miniature, a little god homunculus, desiring, bringing into birth forms, visions, dreams. Sometimes we surprise ourselves and transcend our little alchemist's bottle, entering into a greater sphere. Our experiences there drift back to earth as music, pictures, poetry.

Many an artist has sat before an easel with a fresh canvas facing her, feeling that in its whiteness there is an undisturbed purity, a sense of no beginning, no suffering. The emptiness itself is very satisfying and no mistakes have been made. She knows that once the first stroke is struck, a battle has begun

between realization and failure, because each work somehow must, she thinks, finish by rushing away from her into its own life. No matter how satisfying the elements of a work, its color and composition, and all the excellence, if the painting has not levitated, there is no painting! She lifts her brush and ... but why worry? After all, creation never began and has never stopped. For the universe to exist, creation is going on at every instant.

> *If the sun and moon should doubt,*
> *they'd immediately go out.* —William Blake

There is a part of the artist that wants to create, and a part that wants to let the world alone, and not bring another thing into it.

> *Leaves no trace, like fresh snow* —I Ching

There is some reluctance to condense into words or materials all the distortion, the awkward error that is myself. All the missteps, everything which is unbalanced, distorted, imperfect; the idea of leaving this evidence behind, attached to a name, a persona one has adopted, seems rather awful.

> *In reality the individual never creates anything; if man creates it is as universal man, anonymous, and as manifestation of the Principle. In the ages of truer wisdom artists, scholars and thinkers did not dream of attaching their names to the works which took form through them.*
> —Hubert Benoit

In this age of lesser wisdom, having soiled and signed the surface of many a paper and canvas, I regard my efforts as a

monument to limitation, an index of bewilderment, yet I find in this work something to love—a nascent intelligence searching for beauty, for self-realization, ecstasy, perfection—and it moves me, perhaps with pity; pity for the burden of ignorance, compassion for the spirit and determination, the willingness to drop what has been gained and become empty again. In the end this artist is me—someone both beautiful and ugly, wise and ignorant, young and old. All the duality is there; open, mysterious, vulgar, noble, cowardly, heroic, light and dark all meet in this being.

The relation of the individual to the creative will never be understood logically. What is the reason for something to be? We can only say that a desire arises, and a need, and a happiness in the making of a thing and persevering with it to the point where its own life asserts itself, and that is all we need. Art feels to me like a form of life in itself; a life that is born and dies and is born again in the heart and mind and soul, instant by instant. It is always calling, luring us, so that we may not be afraid to jump off the precipice of the known and plunge into the remotest regions of ourselves. That is reason enough to make the first mark.

Then, having made that first mark, I have to be unwavering in my commitment to reach completion. One mark follows another and the work is realized by movement through time.

The Creative works sublime success, furthering through perseverance...the beginning of all things lies still in the beyond in the form of ideas that have yet to become real...Time is no longer a hindrance but the means of making actual what is potential. —I Ching

So it is not enough to experience the exhilaration of the creative in its first inspired outburst; we have to persevere! In the sphere of art this means we do not abandon a work because we have lost our way. The *I Ching* counsels that just as "The course of the Creative alters and shapes beings until each attains its true, specific nature", so the artist tirelessly alters and shapes the work until all things potential in it find their expression. We accept that art is work, that achievement is seldom instantaneous, and that the creative is fulfilled through duration in time.

> *What a pity! I was just beginning to get it!*
> —Pierre-Auguste Renoir, upon his death at eighty-eight

Another characteristic of the creative is that it is discontinuous with logic and can emerge from the imagination out of nowhere. A creative solution is not found at the end of a long chain of logical thought. It may make its appearance in a dream, at a stoplight, in an overheard conversation. Locked in a little wooden paintbox a cosmos gathers.

The creative is nonlinear, independent of circumstance and condition, sometimes presenting an idea or a direction that is utterly unrelated to the work that has gone before. When every avenue has been explored and every possibility exhausted, in that very exhaustion is a surrender that invites the action of the creative. That is the great value of work on what has been spoiled. Often one selects an unfinished work which has been set aside and, looking at the work in the kindest possible light, recalling the original feeling that generated it, one sets about trying everything possible to bring it out. We may in desperation

cut up the painting, turn it into a collage or a box or book. Sometimes one goes deeper and deeper without seeming to get anywhere, and it is just at the point where effort is useless and the work is lost that a fresh and potent force enters to swiftly enliven, resolve and finish.

The action of the creative is like the springtime when life comes bursting and uncoiling through the soil of dead winter. It is movement arising out of stillness. It is the cause and the means of the outward expression of inner nature.

Even our suffering is part of a creative forward movement. We often find that out of the deepest darkness, a spark ignites, spontaneously. The resurgence of life, the idea, aim, hope or inspiration appears *ex nihilo*—out of nothing—and starts us up again, and how quickly despair can turn to joy! It is this ex nihilo which constitutes part of our attraction to art. We empty our mind of objects, and objects arrive.

The structure of a cumulus cloud, the architecture of a coral reef, the curling horns of an antelope, the pattern of a snake's skin, the impossible metamorphosis of a butterfly, the spider's web, the intricate chambers of a shell, birdsong, the snowflake and the fern, the mouse and the lion, all are the result of the creative pressing forms into life from the mold of archetypes. Exploring every possibility and adaptation, the creative evolves a universe of forms which mirrors the unlimited and ineffable essence of being. The creative is not a force which acts upon nature, it is nature itself in its becoming and shaping.

The artist borrows a little of the creative and manifests its qualities in miniature. Even the most grandiose human schemes are but a fragmentary glimpse of the creative power.

To see its true work, go to the sea, go to the mountains, allow yourself to be dwarfed and humbled by the display of creative potency.

The creative itself is beyond form but it gives rise to all forms, it is timeless but it expresses itself through time.

Pathways
CREATIVE POWER

- Sometimes the Creative is working inwardly and can't be discerned in our outward activity. This is like the season of winter, when life energy withdraws from its display of fruits and flowers and contracts itself into its seed form to incubate. We may experience a feeling of gloom just as winter days can be grey and heavy, yet this introversion is a valuable part of the cycle of creativity. Can you remember times when creative activity appeared in your life and work after such a period of withdrawal?

- How was your creative expression changed by the time of inactivity?

- Did you make a quantum leap?

- Look at the progress of your work in chronological order. How has each expression led to the next? Can you sense the direction of your present work?

- Seeing clearly and accepting where we are in the present allows spontaneity, from which new forms emerge, full of surprises, uncovering unseen aspects of our inner condition.

- To focus and concentrate the creative power, limit for a time the themes and media of your work. When the energy channel narrows in this way, the power gathers, just as a river becomes swifter and deeper when its course is restricted.

- Throw out of your work all that is weak and uncertain. Concentrate on your strongest abilities, joining with the course of the creative rather than hampering it with irrelevant purposes.

- Do not demean your efforts by measuring them by the yardstick of another. If your direction is the slightest bit compromised by opinion, you will lose valuable energy.

- Evaluating your work, know and accept your limitations as well as your gifts. Develop and perfect your expression in every way possible within the boundaries of your abilities and the restrictions of the age. Do not allow yourself to cultivate grandiose notions of who you are and what you are doing. Humility and modesty are becoming attributes in even the greatest artists.

- Reserve a time to approach your work as play. In that time allow every impulse to be materialized. If you are a painter, you can make it a practice to use up whatever paint is left on your palette at the end of a work period. Relax with experiments of no import on discarded canvases or on paper. Observe how work and play are different, and how they are alike.

Reawakening:
OPENING TO THE SELF

*I think your only salvation is in finding yourself, and you will
never find yourself unless you quit preconceiving what you will be
when you have found yourself....Take your head off your heart.*
—Robert Henri

Sometimes it seems as if we are composed of many selves who
battle it out all day long, each aiming for a different goal, alter-
nating in dominance, conflicted and coming to no unified move-
ment, no single "I." Who are we, really? For thousands of years,
people have sought self-knowledge through doctrines, dogma,
practices and prostrations. Theology and philosophy have
offered us one theory after another. To share the knowledge that
has been handed down, we are variously admonished to do this
and not do that.

Yet all on our own we can get there. We can discover our self
with only our art and our breath—and even the art is not essen-
tial, though when it has come to us as a gift there is much we can
do, and we should accept the gift and use it to know ourselves.

Of what use to you is a work of art you create which may be
arresting, inventive and virtuoso, even critically successful? If
this work is not a total movement of your heart and mind
through time, are you really doing your work? Are you discov-

ering yourself in it? To be born and live as a human being in this world is such an odd and interesting event, and it is an all too brief adventure. The truth of this life and the truth of our nature is what we are after; we want to open our eyes, open our hearts, know ourselves.

> *The cathedral is a great diagram of how to enter heaven but to enter requires tremendous skill and this I must acquire through the art of painting.*
> —Morris Graves, upon visiting Chartres

When we were children we asked many questions, and depending on the time and place of our birth and the family we joined, we got an array of fantastic responses. Eventually we discovered the grownups were as ignorant as we were, but by then we had had to give in and take on the portrayal of life which they assigned to us. And yet real life is intrusive; events shake us and we remember the questions—who am I and why am I here? Where did I come from and where am I going? What are we? What is the world, what is this body, and on and on. By the time we remember the questions, they may feel very painful, and thought, which is made up of the known, cannot enter the unknown to bring us back an answer.

In your art you can move with your questions, your yearning and your search. Here you find a way of being that feels complete, that engages the totality that is you. And to gain that freedom you open your spirit into the world, holding nothing back. To get out of the way of the power that is moving through you, think of yourself as an instrument or vessel. In the act of making art you move beyond thought, uniting all the fragment-

ed aspects of your self into a working whole, guided by a scent, a perfume, in the spell of which you may glide or you may stumble, but you are always moving. If we are open, we can create something that comes to us from beyond our conscious awareness. That which is beyond our awareness we finally recognize, through our art, to be ourself.

In this awakening of self there is no certainty. We cannot predict what truth may arrive, and its arrival may require renunciation, because to keep moving, to know the self deeply, we may have to give up many beautiful and beloved objects. A painting may become a beautiful object many times over before it is finished. Only the artist knows if the need has been met, if the questions raised have been fully addressed; if this movement, this dance is complete or merely frozen along the way.

When you must alter, efface or destroy in order to reach your self, it helps to remember that negation also leads to truth.

In a positive sense, negation is merely the dropping of limiting thought patterns which have ruled us and to which we now say "No." We don't have to develop new structures, we just have to let go of the old structures, thoughts and beliefs that imprison us.

For the world is both a Paradise and a prison to different persons. —Thomas Traherne

Paradise is within the prisoner. To liberate the prisoner, remember our true and original nature. In order to remember myself, I have to forget myself. How can I do it?

Most people are familiar with practices of physical relaxation. In such a practice, one assumes a comfortable position,

sitting or lying down, and begins, for example, by focusing on the feet, tensing them and then allowing them to relax, moving unhurriedly through the body, part by part, until the entire body is in a state of relaxation, receptive and fresh. The same approach can be used to relax the mind, progressively letting go of the tension that maintains the psychological contraction which results in our illusory identity; releasing, relaxing and allowing the inner being to breathe and to expand. It is only a first step, but if you do it, you may get the feeling of what is possible.

Begin with the physical relaxation, adding thoughts of appreciation for the body before moving on to relax the mind. As you relax the various parts of the body, be mindful of all the ways it has served you; it is the only thing you can point to and say "here I am."

Think of your body as a self-motivated animal with its own laws and traditions. For example, when you put your attention on the feet, consider how they have supported and carried you on this earthly journey, what an invention they are, all the moving parts; picture the small bones, the graceful arch, the spring of ligaments and tendons.

Relaxing the legs, think of how they have taken a stand, have run and jumped and danced, enjoying the gift of movement, carrying you forward, eager or hesitant, into the next experience. Remembering, not reaching; not reaching for any thing.

Upward through the torso, the lungs and breath, the heart beating, the eyes and ears; the senses of this body we barely know, which works on its own and takes care of us. Give thanks to your body; body not reaching, not reaching for any thing.

Once you are in a state of physical relaxation, listen to your breathing, following it in and out, counting ten or fifteen breaths upon exhalation, without controlling it in any way. Breath not reaching, not reaching for any thing.

Just as you have progressively relaxed the body by moving your attention through it, tensing and letting go, begin to tense and relax the various parts of your psyche, which badly need release. These parts are your name, age and gender, work identity, your relational life, your goals and ideals, your entire image of yourself. Knowing the self requires letting go of the image; letting go of all the images.

By dropping the images, we are letting go of the personal pretension which keeps us bound to a lesser self.

Following the pattern of tensing and relaxing, understand that the psychological equivalent of tensing a muscle is in exercising the ego-fixation of each self-image to its limit, which then, by some strange alchemy, dissolves itself into a real, breathing Person.

Practice tensing and relaxing the mind's images for a while, using the breath as the only response. Have you ever said a word over and over again until its meaning is lost and it is purely a sound? Try this with your own name. Ask "What is my name?" and as the sound of your name is automatically voiced in your mind, divert your thought to your breath. When the question "What is my name?" is asked, let your breath be the conscious response. If you do this long enough it is the end of your name; you can just drop it for a minute and that is a step forward and a new sensation. You may experience this release in as little as two or three minutes.

Each aspect of our accumulated identity can be tensed and relaxed, dissolved in this way. When you think of your work let your mind go full tilt with all the aspiration and worry, all the terrible importance of it for yourself, for others, for posterity. Let your ego soar and plunge with every thought, but keep returning your awareness as much as you are able, to the breath. Just watching and listening to your breathing while unresistingly playing the mental movie of the self-obsession that is your identity, that identity fixation begins to dissolve, to just go away—you can drop it, and a greater space opens. Keep your attention on your breathing, counting breaths, asking who am I, answering with breathing until you have become the breathing and dropped all the elements of your identity—name, work, relationship, gender, everything. This practice can enclose all preconceptions, all the pressures and ideas, every-thing in the mind.

Pathways
GIVING UP

- In effect you have now done away with survival consciousness. Why be governed by concerns of survival when you are not going to survive?

- Even if your being survives in some form it will not be as the manufactured identity you spend so much energy affirming. That identity, that ego is not your whole self and you know it—it will die, so why waste even a moment of life on it?

- There is something so funny about our predicament, because *there is no predicament*, just problems we've agreed to have. But we want to know what is really going on and who we are, if it is not the fictional being we obsess about.

- Since this fictional identity will be left behind eventually, why not let go of it right now, and see what is left? Is anyone there?

- In the midst of the breathing practice, we have no name, we are ageless; we have let go of our past and our future. Now we can forget about the earth, because we are an eternally breathing spirit, have always been and ever shall be, timeless, located nowhere, existing everywhere.

- Use this practice to the point of experiencing the uncontracted identity for a moment; it is a wonderful freedom that gives us a sense of what is possible, because when all the story goes away, there is Somebody there.

- When we are at work, Somebody is the artist and the guide. Somebody has the answer to every question. Somebody possesses the object of every desire.

CHAPTER 7

Imagination:
THE MIND'S EYE

Imagination is more important than knowledge.
—Albert Einstein

What we can imagine, we will eventually believe, because the concept comes before the manifestation. Generally we think of the imagination as the faculty of visualizing mental pictures, illusions, dreams and inventions independent of physical reality. But it is also the power of the imagination that permits us to see the world at all. Out of the inscrutable activity of energy we create our picture of what the world is, and this is sheer imagining.

> *Imagination, thought and concepts are the antechamber to this house. Whenever you see that something has appeared in the antechamber, know for certain that it will appear in the house. All these things which appear in this world, good or evil, first appeared in the antechamber, then here.*
> —Jalal al-Din Rumi

We are born into a rushing chaos of sensations. Gradually, guided by the belief system around us, we imagine, that is, we conceptualize the world as material substance with solid, unchanging beings and things. It is our imagination that gives us our sense of reality and continuity, shaping inchoate energy

vibrations and shifting impressions into an orderly universe that one is capable of living in and moving through.

This is the everyday function of the imagination—to hold the world together, to give form to ideas that we then manifest in our daily life. In this sense, believing is seeing, rather than the other way around. The imagination also projects itself in dreams and memories—as we re-image the sensory and mental perceptions which have already been stored in the mind.

But the highest function of the imagination is in the intuitive reception of information and appearances for which we have no previous context. In a visionary state we are able to see wonders that are beyond our own invention. In the deepest sense the entire universe and everything in it is the product of the imagination. This is the realm of the origin of archetypes and ideas which become realized as the material world.

The imagination may be compared to Adam's dream—he awoke to find it truth. — John Keats

For many visual artists drawing is a vehicle for knowing life, internalizing the visible world, the consensus reality. Artistic perception uses the power of our imagination to inwardly replicate and to project in the mind clear, defined forms extracted from the mirages before us in our search for truth.

No two people see the same thing, though they both stand together before it, because the image in the mind is informed by thought and desire:

The little Shakespeare in the maiden's heart
makes Romeo of a plough-boy on his cart.
—Ralph Waldo Emerson

Knowledge shapes the imagination. An artist thinking of a cathedral, for example, is not going to produce the same mental picture as the imagination of an architect. Although the artist's intuition may guide him to invent a new form of the cathedral, in grasping the truth of forms knowledge enhances the power, depth and richness of the imagination. That is why we study the forms. Our ability to train and refine the imagination gives us a path to walk upon in our work. Through our art we develop the scope and subtlety of the imagination to its fullest. The art of drawing from life and nature enables our inner eye to project images so clearly and completely that we are able to manifest an entire visual language on our paper or canvas. This is not to say that a drawing or painting is first imagined in the artist's mind and then simply transferred to a flat surface, although that is a common misconception. No, in drawing from life the imagination is creating from instant to instant in response to each pulse of light upon the retina, each thought, movement or stroke, one following another in an overlay of insights which gather and collect until the artist's consciousness senses completion.

Often the mind holds an image which it thinks is true until it attempts to render it; then it discovers how patchy and vague its concept really is. When drawing from life the whole key to seeing is not only to observe the thing before you but to possess it internally as fully as possible. The drawing is a map of the mind's geography of forms. As fully as you have understood and received the outward form into yourself, so will you be able to imagine and manifest that form in a two-dimensional, abstract language of your own. Then, seeing what you draw, the viewer will know what you feel.

Pathways
IMAGINING TRUTH

- To demonstrate the value of knowledge to the imagination, look long at some familiar object, then put it out of sight and draw it. Next, draw it again from direct study, keeping it before you as you work. Finally, draw the object again from memory. Comparing the drawings you will easily see the imagination transformed by knowledge.

- Another way of developing the power of the imagination is to draw the part of the subject that you cannot see. If the

model is posed facing you, draw him from the other side, mentally moving around the form, using the imaginative function to project an image of what you can't see. Finally if you need to, walk around the model and correct the drawing.

- Memory is a display of the imagination. Remembering a moment out of the past, we can place ourselves in the scene again in the imagination, inviting new images to grow out of the old. Using the imagination in this way, we are able to dwell in events that moved and shaped us, and to deepen the feeling aspect even further than memory alone allows.

- To do this, think of the process in three steps:

- First, access the memory itself, recalling the original moment or impression logically, what really happened.

- Second, place yourself fully, with all your heart in that moment or event, allowing your imagination to create a continuing stream of events that includes thoughts and sensory impressions.

- Finally, allow yourself to feel deeply about the memory, to experience the sense of happiness or sorrow, whatever was the overriding influence of the impression. This reawakening of feeling is what fuels your inner vision. Depth of feeling is the core experience we want to recover.

- For example:

I REMEMBER: My window, overlooking an alley between two streets, from which I could see the iceman's horse-drawn cart. I can see the horse, the steam from its nostrils. My mother would give me a sliced apple to feed it; I remember the soft lips and whiskers touching my hand and gently accepting the offering; the delicious crunching sound.

I IMAGINE: I am still standing in the alley, the iceman has gone to deliver a block of the frosted ice, I am the only child there, I look up into the liquid eyes of the horse, the sun on

its eyelashes. With one hand I am holding out the apple, with the other I can stroke its coarse creamy mane. I talk to the horse, and it knows me.

I FEEL: I feel perfect joy in being with this animal. I sense its pleasure and I feel an aching love for the horse in this moment when I am allowed to enter its world, to touch it and know its tender and submissive trust, to be in relationship with a being so strong and so gentle, and to know for this instant, which I can now extend indefinitely, that this creature knows and accepts me.

- Exercise your imagination by invention of hypothetical realities; by pretending. Pretend, for example, that you are the last person alive on the earth. Do you create art? If you do, how is it different from what you are making now?

- From the endless inventory of nature, mentally select a simple object you know well, such as an apple. Using all your senses, give it color, texture, smell. Turn it around in your mind, seeing it blush from red to gold. What does the apple want?

- Imagine similarly the face of your lover or some ideal being. Close your eyes and look long into that face, until the face begins to move, to express itself, to look back at you and to speak. What expression is on the face? What is this person saying to you?

- Imagine that everything you see is alive. Rocks can speak and grains of sand have a wish. A book says, "Open me," a coin says, "Take me with you," a blue bowl says, "I am for you. Fill me." Allow the feeling of indwelling light to reveal itself in all you see and let each thing speak its nature. Remember, imagine, feel.

Symbolism:
THE UNIVERSAL LANGUAGE

symbol: *a material object representing something, often something immaterial.* —Webster's Encyclopedic Unabridged Dictionary

We are unique among all animals in our use of imaginative projection. Language, mathematics, the atomic table, every highway sign are made of symbols—forms projecting from the mind into the world. In their semiotic, informational aspect, these forms represent simple concepts identifying themselves to a viewer.

> *The constellations, animals and plants, stones and the countryside were the tutors of primitive man.*
> —J. E. Cirlot

In science, symbols are precise and unambiguous. Two plus two equals four; color is measurable as wavelengths of light; H is always hydrogen. Once the symbolic language of such a logical system has been mastered, there is no need for interpretation.

The expressive capacity of our language is derived from a remarkably limited series of twenty-six symbols, yet there is no end of things that can be said or written, and language is adequate to communicate the thought that uses it. But art does not exist for the purpose of communication. This would suggest that the expression, or the idea, exists full-blown in the artist's awareness and is then presented outwardly for the purpose of communicating with a reader or viewer, and this is not the case.

In art, forms contain, depict and give birth to complex orchestrations of thought and feeling. Through images, information flows from the individual mind to the collective mind, and from the collective mind to the individual mind. The unknown takes a shape and begins to be seen or voiced according to some tradition or institution. An idea flows from chaos into form, expressing the soul of an artist. Such a work has a life of its own, a material and a subtle body.

Writers write for themselves and not for their readers. Art has nothing to do with communication between person and person, only with communication between different parts of a person's mind. —Rebecca West

In the midst of creative activity, things appear which had no existence before. Every word, every mark leads to the next, and that which is unbidden makes itself known. That is the way creative energy operates. **Nothing can be felt as new if it has been seen before, but nothing can ever have been seen before if it is felt as new, that is, if it is truly experienced in the present moment.**

Each new work is itself a symbol, transmuting into form the movement of thought and feeling for which no other form could ever suffice, a discovery even to the creator. This new symbol arrives out of the nuance of color, or the strokes of a pencil, the sweep of the brush, the fingers in clay, a line with its force; every form has its life in the mind. Attempt emptiness, you cannot get there. Once a mark has been made, there can be no pure form.

When used in the context of an artwork, an angel, a demon, a dragon, a rose, the sea, the sky, a shell, a mountain—all are really elements of ourselves. Even in nonobjective art there is still color or the renunciation of color, shape and negation of shape, for we have to remember that negation is also a positive gesture.

Every system of belief concerning the relation of cosmic law to human fate is replete with graphic symbols. Incorporated in objects from amulets to architecture since the Paleolithic era, graphic emblems and images reveal our relation to the univer-

sal, pointing out landmarks of personal transformation and guiding our participation in eternal principles and values.

Yet it is not so easy to know the source through its forms. One sees what one has learned to see. **A symbol system is a code that must be deciphered in order for its embedded knowledge to be retrieved.** Music, mathematics, alchemy, architecture, augury, agriculture, every craft and trade, the stuff of dreams and fancies, every type of bird and flower, every earthly and heavenly element, the wind, rock and flame; all have at some time offered themselves to representation in words or pictures for the sake of confirming, preserving and conveying knowledge. For the artist who is awake to them, such images are not mere signs.

> *These spiritual manifestations are not...substitutes for living things—are not lifeless effigies; they are the fruits of the inner life perpetually flowing out from the unconscious, in a way which can be compared with the gradual unfolding of creation. Just as creation determines the burgeoning of beings and objects, so psychic energy flowers into an image, an entity marking the true borders between the informal and the conceptual, between darkness and light.*
> —J. E. Cirlot

The exact origin of symbols is obscured by time, culture and other variables, but the meaning can still be known within the overriding influence of the universal archetypes that resonate for all people. Recognition of the archetypes presupposes their transmission throughout the collective unconscious, with symbols as their primary language, carrying meaning directly from deep layers of the psyche not accessible to reason. In the view

of the symbolist artist, the uncertain origin of a symbol does not weaken its legitimacy—if anything, this mystery is embraced as an intensifying power of the unconscious. In the late nineteenth century an entire school of art and literature arose out of this fascination and attraction to the mysterious.

Often symbols evoke contradictory meanings, yet this contradiction is itself a symbolic demonstration of the duality that permeates all life. Fire, for example, is a symbol of warmth, sex and the vital energy that drives and preserves our life; it is at the same time, in its negative or purifying aspect, a symbol of destruction. The interpretation of the particular image is colored by its historic and cultural context, but the experience of human life is not so very diversified. In all times and all places, humans have awakened to the light of day, toiled in the heat of the sun, waited for water and the fruition of plant life, observed the changing seasons, looked up to the stars, witnessed birth and death. We are all traveling the same road; we are more alike than we are different. **It is the common experience of humankind that resonates through any symbol and gives it its truth.** The sun, moon and stars display to all people the essence and movement of a unitive force as it expands, radiates and illumines everything in existence. The myths and histories vary, but the essential subject is always the same.

Even the survival instinct often involves the recognition of an image, as in the case of baby chicks, who will hide when the silhouette of a hawk is held above them. Clearly there is an inborn ability to recognize significant form. Color patterns and other physical attributes are known to trigger various behaviors in feeding, mating and fighting.

The earliest symbol system was probably prehistoric astrobiology, when the stars and their movements were first thought to directly influence earthly life. In addition to the symbolic meanings of objects, the abstract elements of form, such as dot, line, plane, volume and color have their own profound implications. No representation is without meaning. No matter how abstract or nonobjective it may purport to be, it can't be about nothing. It can never attain pure formalism. Every form bespeaks itself. The only "pure" form is no form. Once a mark is made, it cannot escape the mind's associative instinct; everything represents something. A few entries from Cirlot's *Dictionary of Symbols* will illustrate the way symbolic form permeates consciousness and operates on more than one level at a time:

> STAR: As a light shining in the darkness, the star is a symbol of the spirit...however the star very rarely carries a single meaning—it nearly always alludes to multiplicity, in which case it stands for the forces of the spirit struggling against the forces of darkness. This is a meaning which has been incorporated into emblematic art all over the world. For this reason 'identification with the star' is possible only to the chosen few. Jung recalls the Mithraic saying 'I am a star which goes with thee and shines out of the depths.' Now individual stars are often seen in graphic symbolism. Their meaning frequently depends upon their shape, the number of points, the manner of their arrangement, and their colour (if any). The 'flaming star' is a symbol of the mystic Centre—of the force of the universe in expansion. The five-pointed star is the most common. As far back as in the days of Egyptian hieroglyphics it signifies 'rising upwards towards the point of origin',

and formed parts of such words as 'to bring up', 'to edu-cate', 'the teacher', etc. The inverted five-pointed star is a symbol of the infernal as used in black magic.

CHILD: A symbol of the future, as opposed to the old man who signifies the past; but the child is also symbolic of that stage of life when the old man, transformed, acquires a new simplicity—as Nietzsche implied in Thus Spake Zarathustra when dealing with the 'three transformations.' Hence the conception of the child as symbolic of the 'mystic centre' and as the 'youthful, re-awakening force.' In Christian iconography, children often appear as angels; on the aesthetic plane they are found as putti in Baroque grotesques and ornamentations; and in traditional sym-bology they are dwarfs or Cabiri. In every case, Jung argues, they symbolize formative forces of the uncon-scious of a beneficent and protective kind. Psychologi-cally speaking, the child is of the soul—the product of the coniunctio between the unconscious and consciousness: one dreams of a child when some great spiritual change is about to take place under favorable circumstances. The mystic child who solves riddles and teaches wisdom is an archetypal figure having the same significance, but on the mythic plane of the general collective, and is an aspect of the heroic child who liberates the world from monsters. In alchemy, the child wearing a crown or regal garments is a symbol of the philosopher's stone, that is, of the supreme realization of mystic identification with the 'god within us' and with the eternal.

COBWEB: Apart from its association with the spider, the symbolism of the spider's web is identical with that of fab-ric. Because of its spiral shape, it also embraces the idea

of creation and development—of the wheel and its centre. But in this case death and destruction lurk at the centre, so that the web with the spider in the middle comes to symbolize what Medusa the Gorgon represents when located in the centre of certain mosaics: the consuming whirlwind. It is probably a symbol of the negative aspect of the universe, representing the Gnostic view that evil is not only on the periphery of the Wheel of Transformations but in its very centre—that is, in its Origin.

We can observe the repeated appearance of symbolic forms in our work and the feelings we experience in contemplating them. Certain images will exert an unusual attraction for our imagination and can be better understood if we research their appearance in the world's religions, myths and histories. In support of the universality of symbols, esoteric and mystical schools of all cultures are remarkably consistent. It seems that in its essence a horse is a horse is a horse, yet each of us must look to discover our own symbol system, in order to address our own most pressing enigma.

What is within is also without.
—Johann Wolfgang von Goethe

Pathways

MIRROR IMAGE

- Recognize your own symbol system. Search out the recurring forms and images in your:

- ART: As subject matter and the background of your subject matter. As the meaning inherent in the tools and media you use, such as the transparency of watercolor or the physical density of oils, and the type of surface on which you apply them, your choice of colors, your visual orientation, such as horizontality, flatness or dimensionality, and your focus on mental, sensual and/or spiritual states. Understanding our own direction of self-expression increases the power we have to achieve it.

- SPEECH: Observing our use of various metaphors and figures of speech shows us which symbols are the signposts of

our thoughts. Simply listening to our own voice speaking reveals our self-nature and our way of imagining the world.

- DREAMS: Keeping a dream log intermittently, or simply taking a few moments to list the symbols that appear repeatedly in our dreams, is a way of bringing our real concerns to the foreground of awareness.

- HOME: Take photographs of each room of your home. Using a fisheye lens if you have one, try to include an entire room in each picture. Think of the pictures as a series of self-portraits that reveal the rooms of your consciousness, containing all the objects of your thoughts and desires, the symbols and souvenirs of your earthly attachment.

- Create an Informal Mandala

Most artistic formats, pages of the written word, and created objects project a world of reason, and every human endeavor displays a love of order. From birth the mind struggles up from the unconscious to possess the physical world, to find safety, to learn, to achieve, to regain love and to return to the garden. In contrast to the natural world, most of the forms in our created garden are of a logical, four-square, right-angled design, but we want to penetrate the unconscious, whose contours are free-form.

One way to enter the unconscious imagery, and to see my personal symbol system displayed, is to work within a circular format, creating a mandala of myself.

On a square canvas or paper draw or paint a circle, leaving a section open as a door for things to come in and go out. Within the circle there is no top or bottom, no left or right. The only direction is inside/outside. Gazing, I become aware of a center, and I can feel the center pushing outward and the circumference drawing itself together—an expanding and contracting like breathing. In the center I draw myself in any way that feels right to me. As I gaze, I may see figures, faces, animals, my

lover, my vision of happiness, the beast that stands in my way, the garden I remember, the ocean, the sky, my demons, ghosts, protectors and destroyers, I let them come in, they can all come in and find a place in the circle.

This picture does not represent anything permanent. It is only now, only a picture of this moment, so anything can come and go. Nothing is necessary and nothing is irrelevant, there is nothing to live up to. Like cream in a cup of coffee, the personae swirl into patterns for awhile and dissolve, just configurations of feeling. No monument, just a dream, and in this spirit of dreaming I look at what has come from my mind's eye into the picture. This is the circle of my self this day, giving form to the all and everything that inhabits and surrounds me. I am the content of the circle and I may represent myself as any thing. Now I am some bird, or a baby, an old woman or man, I am a character out of myth, a spider or a fish, a star or a germ under the microscope, I am Zeus on Mount Olympus.

Like the meditational yantras of Eastern meditation, my mandala defines, distinguishes and brings together all my fragmented parts in a circular, non-hierarchical unity. My universe floats around me without concern for spatial or narrative logic. What is built up touches what is torn down, what holds together is the twin of what falls apart, what shelters me, what shuts me out—all make their appearance. My mandala may contain an abundance of objects or only a few things, even a single figure in space. The choice of a circular visual field allows images to shape themselves without hindrance, without censorship, into a mirror of my mind.

> *...each for the joy of working,*
> *and each in his separate star*
> *Shall draw the Thing as he sees It*
> *For the God of Things as They are.*
> —Rudyard Kipling

- Pay attention when you have a feeling you might describe as superstitious. Does an object or event ever strike you as a portent? Explore the symbolic content of the object or happening.

- Be aware when you have a sense of interest in something that is outside your usual frame of reference and concerns. Identify the thought-essence of this unfamiliar focus. Spend some time with it instead of disregarding it as irrelevant. Nothing is irrelevant; everything has meaning.

- Incubate a symbol for a feeling you have.

- Research your recurring symbols in:

Dictionary of Symbols
by J. E. Cirlot, Barnes & Noble

The Herder Symbol Dictionary
Translated by Boris Matthews, Chiron Publications

Dictionary of Subjects and Symbols in Art
by James Hall, Harper & Row

The Penguin Dictionary of Symbols
by Jean Chevalier and Alain Gheerbrant
Translated by John Buchanan-Brown, Penguin Books

Chaos:
LEONARDO'S INK BOTTLE

Catch the accidents, and make a science of them.
—Auguste Rodin

What is chaos? Is there a period, process or place in the universe whose essence is disorder? Or is what we perceive as disorder merely a reaction of the mind to a transition from one form or structure to another, the unfamiliar rhythms of an unknown process? It is difficult now to imagine the general reaction to the work of Jackson Pollock in the fifties, before time had revealed the order and rhythms of his painting. The work was thought of as "accidental" and chaotic. There is a story that after his death the large paintings were cut up and the pieces sold separately, since any part was as inscrutable and chaotic as any other part. I think our consciousness has evolved considerably since the invention of that story. Pollock was trying to bypass memory and touch the preconscious at a time when the popular mind was just opening to Freud. Now, when we have met with Jung and gone well beyond him, Pollock's efforts seem less relevant.

But an artist can always find a muse in chaos, in the preconscious:

> chaos: The infinity of space or formless matter supposed to have preceded the existence of the ordered universe.
> —Webster's Encyclopedic Dictionary

Is chaos unformed and potential existence, the wild swing of uncoupled energies? Imagine a hurricane. From a satellite we would be able to see the orderly spiraling of a continent of clouds that sweeps everything beneath it into frenzied motion. From above, order, below all is in chaos, and it all depends upon the perspective of observation.

> Chaos: the earliest state of disorganized creation, blindly impelled towards the creation of a new order of phenomena

of hidden meanings. Blavatsky, for example, asks: 'What is primordial chaos but the ether containing within itself all forms and all beings, all the seeds of universal creation?' Plato and the Pythagoreans maintained that this 'primordial substance' was the soul of the world. —J. E. Cirlot

To tumble stones in a drum where they strike and rub against each other is a way to polish and bring out the beauty of colorful and precious pebbles. But to *be* one of the stones that is struck repeatedly and tossed against our desire to be at rest, is chaos. So little do we know about the tumbler we are in, and even less of that Lapidary! So when we are struck by fate we don't know why—there seems no rhyme or reason to it. Whatever disturbs us that we can't reason out makes us feel that our life is chaotic. At times the orchestration of energies that operate our lives, our art, may be discordant, but we have faith that even discord leads to resolution if we persevere and keep moving.

Think of a living body as an example of structure and order. When the body dies, it begins to disintegrate. The life of the spirit having moved on, the body cells lose their relationship to each other, their cooperative and collective functioning. What unified them and gave them a common purpose is gone. These cells then decay and the elements that constituted them escape their bondage to the body, returning to their separate essences, and, until they are mustered into forms again, they regain their original pure nature. The body that was loses its identity as a body; this is chaos for the body, but order for its elements.

One system of order breaks down; for a while there is chaos. One system overwhelms another; for a while there is chaos.

LEONARDO'S INK BOTTLE

When an irresistible force meets an immovable object, again, chaos. But the seemingly random mingling of forces releases energy. What does this mean for the artist? It means that we can channel the power of chaos to find release from the prison of our own thought, our formulaic ways of seeing and responding.

Leonardo wrote in his notebooks of hurling a bottle of ink at the wall, and out of the impact and chaos of the explosion, finding new images to surprise the imagination and refresh the faculty of visualization. The artist found in the curious shapes, the stains, drips and diffusions, a new vitality.

Sell your knowledge and buy bewilderment.
—Jalal al-Din Rumi

I know my mind as a repetitive circular movement, constantly reshuffling the same deck over and over. The chaos of accident and random natural form presents me with new configurations. Something is born which I could not have invented; it invents itself and always declares nature as its source. In the great scheme of things I know my thoughts are so trivial that I can't fail but be reduced to grateful dust, safely drifting in the sensitive chaos of the unknown. I will still be here with all my gifts, skills and structures, but I want to come to myself anew. This chaos in my mind and heart is the very germ and beginning of consciousness, before my being has had a chance to know itself, but after it has awakened to its existence. How many times a minute this is taking place I cannot tell!

Pathways
ACCIDENTAL ORDER

- GAZING

An entryway to the serendipitous order of chaos is the prac-
tice of gazing. Through looking steadily, with eyes relaxed, at
any space within ourselves or in the outer world, infinite
forms reveal themselves. One can gaze at any object to med-
itate or concentrate, but to see into chaos, gaze where there
is no object to be found. Any formlessness, any emptiness is
a suitable surface for the dedicated gazer. A plaster wall with
its slight variations of texture and light, the churning surface
of the sea, a mottled sky, the face of a smooth rock, an
expanse of sand can become a screen upon which circles,
spirals, faces and figures dance. The only trick is to relax the
focus of the eyes to see all things. One only has to be at ease

and unhurried, receptive and open, having no particular goal or expectation. It is always the mind that forms the idea out of the formless. This whole world is imagined in that very play of thought.

- SEEING IN

 Of random design, jasper, malachite, quartzes and all kinds of stones display almost photographic representations to the receptive eye. As a young artist, I lived in New York in an apartment building that featured a marble entry hall. Where the elevator opened was the unmistakable picture of a copulating couple, distinctly delineated in reticulated marble with a base of buff and veins of burnt sienna streaked with rose and pink. Fleshly paradise at the call button. As I waited for the elevator I watched the other residents to see if they noticed. I lived there for five years and never saw the slightest indication that anyone saw it but me, and I could not stop seeing it!

- Studying what forms out of the chaos I see my own nature reflected as the visible world.

- When skill has mastered the artist instead of the other way round, stagnation occurs. That is a good time to explore chaos. If you are facile in a medium, abandon it for a tool you have no control over. Or throw that bottle of ink at the wall and come back later to look into the hallucinations, the faces, bodies, animals, landscapes. Embrace the accident! Isn't it every artist's ambition to create joyfully and spontaneously? O mockingbird, you are all I need while you sing!

Solitude:
ALONE BUT NOT LONELY

Harken to the flute and listen to what it says
It complains of the pain of separation.
It says: Ever since I have been cut apart from my bamboo stem
My cry has set men and women weeping.
— Jalal al-Din Rumi

Being alone, we are not so lonely. Time expands, now we have all the time in the world. Time to imagine, to play with an idea, project a possibility.

There are forms of expression that are cooperative, such as theatre, dance and movies, and for many people these arts are their best form of expression, working with others toward a result.

But for the writer and for the painter, we must have solitude to wander mentally, to explore deeply, to reflect, to experience ourselves and to create.

Some of the resistance we feel about our work is just apprehensiveness about complete solitude, but we are most ourselves when alone. The company of just one other person can be so intoxicating that we lose ourselves in merging with another. Relationship is surely an essential aspect of our lives and a channel of experience, sharing and happiness. Yet we must, if we want to plumb the inner depths, reserve great blocks of time to be alone.

An artist at work is relating to the many persons composing the self, relating to pigment or to clay and its texture, its body and malleability—thoughts and ideas present and shape themselves and we walk into time alone, into a new light, a new moment, a realization, a happiness which is not, for us, to be found any other way.

Aloneness implies a mind that is deeply, inwardly without any sense of fear and therefore without any sense of conflict.
—J. Krishnamurti

Welcome solitude, don't evade boredom, restlessness or the

panic of isolation. These feelings are steps toward the threshold of a new work.

Stay alone for long periods of time, especially when you are tense, lonely or depressed. At such times the mind's urging is for escape from the uncomfortable disconnectedness. Yet I have found that, when seeking escape through the company of others or the distraction of activities, I fail to make the full descent into my self which is required for a breakthrough. Sometimes we just have to let ourselves drop beneath the surface of the inner ocean.

As artists, our specialized function is feeling, and we have to know that every feeling, if it is deeply experienced, is an entry to a fuller life, a fuller creation. We have to do all we can to allow feeling to flow; even when it is the feeling of despair, we have to be willing to go there, to be immersed in it, to explore it and to gather from it fuel for our crucible of art.

In solitude we can slow down. We can listen long hours to music we love, and gaze openly, timelessly into our own work. Artists spend a great deal of time merely looking at a work in progress, letting it operate its latent magic upon us, so we may understand the direction of our next effort. Once a work has begun, it is always telling us where it wants to go. We have to keep our receptive awareness and this is where solitude is essential. Undistracted, we can enter into and maintain the profound realm of our mind and emotions. Without undistracted solitude, we should never find the way. If a person cannot tolerate long stretches of time alone, they are not meant for this work.

An artist is always alone—if he is an artist...the artist needs loneliness. —Henry Miller

Pathways

PERFECT ALONENESS

There are some thought processes that come forward in solitude that contribute to opening new areas of creative action. In addition to our known or practiced forms of meditation and mindfulness, there is the quality of serendipity, which is most enjoyed when one is alone, and which can yield freshness and new directions:

- Wander about the studio and bring out old and forgotten work. Browse through old drawings and sketchbooks and you will be surprised at the abundance of worthy, half-explored insights and ideas, that, seen in the light of the present, offer an entirely new direction and reconnect us with vital artistic energy. This is a good passive opening for the times when we are not motivated to work.

- As well as looking at your forgotten work, look into books you acquired and did not read, or have not read in some time. Reopen your James Joyce, your poetry books, those obscure volumes that captured you briefly and were retired to the shelf unread. Each book in your home represents something that moved you. Go back there. Read the text of a book you bought for its pictures.

- Go through your CD's, tapes and records. Find the music you have loved. Play it while you do nothing but listen.

- Gather all your photographs into one place, even if you simply put them in a shoe box. We all have a virtual history of our lives in casual snapshots. Viewing them is a way of resensitizing ourselves to our own experience, and may help us to cultivate compassion for ourselves.

- Walk, not briskly for the purpose of physical development, but for observation of the world around us. Walking slowly, we see many things that are invisible to the exercise walker. We are able to witness the small things of nature, such as insects and grasses, the effect upon a spider's web of the breeze or the mist, and the great things of nature such as the sky and its population of clouds and lights, the movement of birds. We also notice changes in our own body and way of seeing. For example, if you have been walking for a while and stop moving, you will notice the illusion that the landscape, the sky is moving away from you. This makes us aware that our vision is not objective, but has adjusted itself to our body's movement. This visual effect takes a moment or two to wear off. Try it as a way of playing with your eyes. Look at the world upside down and notice the effect upon color of the change in the position of your head. Lie down and discover that when the head is in a horizontal position, one eye is more sensitive to warm colors and the other to cool. What else can you find out serendipitously?

Courage:
FACING A WORLD
OF HORROR

Behold I am become Death, the Destroyer of Worlds
—Bhagavad Gita

The newspaper shows me a glossy-haired young woman, no more than nineteen, who seems asleep, her lovely features in repose. Her face is coolly and beautifully carved, her skin perfect, except for a couple of small dark spots on her cheek and forehead. Her graceful hand curves from an open arm, fingers slightly curled. She is dead, along with the perfect six-day-old baby laid beside her. Over them an old grandmother wails. Some Tamil village war.

How can I live in this world? I ask the face in the mirror. How can we live in this world. How can we think of joy and creation when the fragile petals of beauty are tormented and blasted to oblivion daily?

I face my canvas, I mix my colors through wet eyes and I paint. This work I am facing is an image of romantic love, with figures floating through a luminous sky, stars glowing, dreamers' lips just touching. The strokes I place now, who knows what

they will say? Will they add pain to the picture of love or lift me away from the sorrow, into a fantasy of blue and silver, pearl and rose, merging with the dream and forgetting the ugly world of fear and death?

Still painting, how can I?

In this time of repression and conformity where fear and confusion pervade our daily experience, we have to stay steady; the world is barely less ephemeral than we ourselves and there never was any certainty. Do we yearn for our mother's breast, our father's hand? Remember, a greater and grander realm exists within ourselves, forever perfect and undisturbed.

In the midst of pain and turmoil I look up at the blue sky, the first plum blossoms; a voice inside says, Oh! I am happy! There it is, the swelling joy of merely being alive another day. Is this life an inspiration or a cruel joke?

We can't let ourselves become fearful and disillusioned when we see the shape of destruction, misfortune and indifference that surrounds and infuses our life. This is the price we have paid to purchase the experience of life. The things that repel us are the natural qualities of the material world, whose essence is transitory. The beauty we perceive is something real inside of us, reflecting the eternal. That is why the ecstasy that beauty inspires overcomes the press of TIME. It is the monad, the soul, the individual experiencing our immortal being through manifest experience, and with this gift dualities dissolve, the timeless unmanifested self is united with forms, both to know joy and, ineluctably, to experience suffering. We have to be willing to receive the whole spectrum

of life. That is why it is natural to suffer in our work as well as to find great release. If we accept this totality, we expand in all directions at once, sailing over the painful moments, over oppressive time, knowing nothing depends upon the outcome. If we can paint, if we can be, as if nothing depends upon the outcome, we are free. Beautiful unity of essence and manifestation, intuition and invention; creation anew, light upon the spirit, that is our art.

NOTHING DEPENDS ON THE OUTCOME.

In life and in art, seeing the darkness brings out the light.

Going deeply into being with ourselves, we will find a need to abandon the newspapers, TV and movies for periods of time. We are held fast to our society and culture through these vehicles; they are presented as if they reflect a real world but we know they do not. They are constructs of thought that seek the lowest common denominator, because that is how the participants make their money. It only takes a few days of media-withdrawal to restore our natural mental and emotional rhythms, which have their own irrepressible optimism.

We can tune out the horror and reclaim the hope that springs eternal. Or if we can't break the habit of reading the newspaper, we can throw it aside in the morning and read it later, after we have shaped a day. Observe how the TV news is calculated to alarm us. How its narratives revolve around our basest fears. What is real is right here inside your head and heart.

Are we depressed, frightened, despairing? Go to the window. What do you see out there? What is real? Perhaps it is raining, there are puddles on the ground, the soft light of the

cloudy sky calms and pulls together the colors and brings a
softness to the air. Stay at your window for a long time, listen-
ing to the rain, the water rushing in the gutter, the bubbling
sound. Think of the happiness in the roots of plants, the
underground world of worms and seeds and corms, all waiting
for spring, and there is consolation in this watching and lis-
tening.

Pathways
ABANDONING FEAR

- Choose a day each week to tune out mass media. Turn off the television, do not read newspapers and magazines, do not go to current movies, do not listen to commercial radio stations, and do not communicate through your computer, or browse the net.

- Keep your media usage confined to preselected books and music on your own tapes or CDs. Work on art or write a letter.

- Walk out in the real world every day.

- Talk to real people and listen to them talk to you. Is there a killing around every corner, or are most people where you live kind and helpful?

- Is the media world of horror any different from your nightmares? Have any of your nightmares been spawned on TV?

- Observe how everything in the media is profit-based. When you read newspapers and magazines, ask yourself who profits from the appearance of news about events, politics, fashion, reviews of the arts.

- Why is there so much mediocre and irrelevant material? How much of this is simply a justification for pages of advertising and hours of commercials? What really drives the media? Have you purchased anything lately that you do not need? Why?

- How does it profit the media to portray the horrors of accidents, gang wars, natural disasters? Would you be missing essential information if you turned the other way for a week? A month? A year?

CHAPTER 12

Dreaming:
SEEING WITH EYES CLOSED

It was the wise Zeno that said, he could collect a man by his dreams.
For then the soul, stated in a deep repose, betrayed her true affections:
which, in the busy day, she would rather not show, or not note.
—Owen Felltham

Dreams are often thought to be the artist's primary domain; we awaken with our dreams before us and live with them all day long. Time sifts the emotions and distills the substance of our dreams as we hold them up to the light of consciousness. We can mine the dream for its wealth of motifs, images and symbols, which convey important messages from the unconscious. The power of many a work of art is that it releases an emotion that is alive in the unconscious of every person—a note is struck that resonates in every proximate instrument, and we are in the sway of art as we are in the sway of dreams. To reap the abundance that dreams offer us is easy; you only have to remember.

There are two ways to utilize the dream state for revelation, inspiration and self-development: remembrance of dreams and recollection of them in the waking state; and remembrance within the dream state itself that we are dreaming. This phenomenon of lucid dreaming is available with a bit of training, and it shows us that the line that separates wakeful impressions and dreaming impressions is only a filament of belief.

REMEMBRANCE IN A WAKING STATE

Remembrance and mindfulness of the dream state when we are awake is like meditation with an object. In this meditation the dream is the object we hold in our attention upon awakening. With our pencil and notebook we replay the dream sequences and immediately write them down. Even if we can't recall the entire dream, we write down the scenes and features that we do

remember. It is very important to make the notes because without them, the material is quickly lost or diluted. In writing and drawing the dream immediately we are using the easy method, simply parting a curtain that conceals the magic show of the dream. If we keep such a journal consistently we begin to see the themes of our life and to understand our gifts and our destiny. Our gods, guardians and demons are showing themselves to us all night long.

Dreaming itself is a subject matter for art: the etchings of Goya, the paintings of Magritte, Dali, De Chirico, Delvaux and other surrealists; the works of the Symbolists of the late nineteenth century often have dreams as a motif, recognizing in them a source of knowledge and guidance, a vehicle for the visitation of spirits and a source of precognition.

Unlike the psychologist, the artist need not analyze the dream to participate in its meaning. Manipulating and representing the imagery of the dream, the artist can find resolution, understanding and self-knowledge in its symbols, in its story and emotional content. Who would not be willing to fulfill their mission in life if only they could know what that mission is! We have within us the answer to every question.

When we receive gifts in the dream state and then act upon these promptings, we make a dream a reality. By materializing our dreams we awaken feelings through ideas and awaken ideas through feelings, and both functions are subsumed in a higher state of awareness. Dreams are our own personal symbol systems, complete in themselves, and, if they could be fully understood, they would be seen to demonstrate truth at every level.

REMEMBRANCE WITHIN THE DREAM STATE

All that we see or seem
Is but a dream within a dream.
—Edgar Allan Poe

The second form of remembrance we can use to consciously connect with the dream state is to remember while we are dreaming, that we *are* dreaming.

Some people experience lucid dreaming spontaneously, but we can train ourselves to know that we have fallen asleep and are having a dream. When we experience lucid dreaming we are no longer at the mercy of the dream. With awareness we are fearless and we know that the fire cannot burn us, the flood cannot drown us. We are not afraid in the midst of whatever calamity appears. Not only can we know that we are dreaming, but we can direct the content of the dream and introduce whatever material we wish.

How is it that this skill can be learned? It must be that there is not a substantial difference or separation between the waking consciousness and the dreaming consciousness. Could it be that perception in both spheres is full of illusion?

Row, row, row your boat
gently down the stream,
Merrily, merrily, merrily, merrily,
Life is but a dream.

In the literature of Tibetan dream yoga, we are told that we can induce lucid dreaming by practicing the awareness during the day that all appearances are unreal. By looking upon our so-called waking life as insubstantial and evanescent, we are dis-

solving our belief in the solidity of the material world, and conditioning ourselves to be aware at night that we are dreaming. Therefore, it becomes automatic to recognize the unreality of the illusions that appear when we are asleep. "I am sleeping, surely this is a dream." Then, when threatening or frightful images appear, we can alter them. Not only will we be unafraid, but we can turn hot to cold, night to day. We can transform a wrathful deity into a nurturing mother.

> *...bear in mind that, in general, nothing is truly existent and, in particular, recognize events as dreams. Thus, establish single-pointed meditative equipoise in the awareness, "I have fallen asleep. This appearance is a dream. It is an illusion. I have certainly fallen asleep.*
> —Lochen Dharma Shri

Pathways
DREAM STATE

The power of dreams to shape our lives is as deep as we allow it to be. What is the benefit of dreaming gifts, such as the ability to speak in another language, to write beautiful poems, music and songs, conceive artistic or even scientific insights, if we do not carry the treasure back to the conscious mind? That is why it is so important to make notes immediately upon waking. If you wake and do not recall your dream, it may help to move your head back to the position it was in when you woke, and to wait calmly a little while to see if you regain recall. Make a habit of dream recall as the first mental activity of your day.

- Did you dream last night? Do you remember the dream? Can you write or draw it?

- For complete information on the ways of recalling, using and controlling your dreams, read CREATIVE DREAMING by Patricia Garfield, Ph.D. Simon & Schuster 1974. To understand the dream state and its use in developing self-mastery, read ANCIENT WISDOM by Venerable Gyatrul Rinpoche containing the Nyingma teachings on dream yoga, meditation and transformation. Snow Lion Publications 1993.

- Use the imagery of your dreams as motifs for your work. See where this leads.

- Think of the dreams you have had that revealed lessons about your art. Did you use the lessons?

For example: Many years ago I dreamed of standing at a table on which was a porcelain bowl filled with a mixture of colored oil swirling in water. I put my hand into the bowl and when I withdrew it, my fingers burst into flames. At the time I had been painting watercolors, but I took the dream to mean that, were I to devote myself to oil painting, I would

experience a combustion of forces that would take me further. And so, despite my initial dislike of oil paint; its viscosity, its resistance to the surface of the canvas, its fragility of color which was so easily degraded by mixing, I stayed with it, and over the years some of my greatest moments as an artist have come from working in this medium. Whenever I despaired of mastering it, I remembered the dream and persevered.

Another lesson came when I dreamed I was painting a seascape. As I worked, the sea began to rise and the waves to roll. Well, I thought, this is pretty good, I'm now able to evoke the living sea, and as I looked, I decided to place just one more stroke of white into the churning waves, and as I did, the entire scene froze and lost the life it had—it was just another picture and nothing I did could bring it back. The dream had shown me the delicate edge that divides spontaneous, spirit-driven expression from mere technical mastery, and how subtle is the balance of these two aspects to preserve the innocence of a heartfelt emotion; just one insincere stroke and all is lost.

And in case I had not heeded the lesson, it was given to me again at a time when I was working in clay. In this dream I was the apprentice of a master sculptor. As I watched her work, she took handfuls of wet clay and slung them onto a slab. She made a few quick touches and the clay was a head; a moving, speaking head that was alive. I turned to my own work, to the clay she had given me. Holding a lump in my hand, I squeezed it until the clay squished out between my fingers. Looking down, I saw a figure like a Shiva, with many arms that were waving; the little figure danced and turned in my hand. Oh, I thought, this is pretty good, and I wanted to add some detail to the fingers and face, but as I did so, the arms stopped moving and the little goddess was nothing more than a crude doll. I looked at my mentor with dismay,

but she only shook her head sadly and went back to her own work. To be an artist was to call forth life itself, having nothing to do with making things as a goal. The things were only the debris left behind by the action of the self.

I wandered in pursuit of my own self. I was the traveler, and
I am the destination, says Iqbal.
— Jalal al-Din Rumi

My final example is one of lucid dreaming, in which the subject of the dream was dreaming itself. In this dream I entered my house and saw my dog bloody and badly hurt. But as I went to him, something in me paused and I said to myself, "No, I'm not going to look, because there's something funny going on here, I think maybe this is a dream." So I turned away from the dog and walked into the living room where a group of people, all strangers to me, were sitting about on chairs. "I don't know you," I said. "What are we all doing here together? I think we are all dreaming." At that moment a dark man entered the house. He pointed to the people one after another, saying "Wake up!" and one by one they disappeared. I wanted him to wake me up too, because I didn't want my dog to be hurt, I wanted this to be a dream, but he didn't point to me. "But it must be a dream," I thought, and suddenly I heard a thud. In the gusty winds of a stormy night, a little Balinese doll with pointed fingers had fallen off a shelf and landed right next to my head, awakening me. "I knew it was a dream," I thought with relief. Two days later I attended a talk by Lama Tharchin Rinpoche in which he remarked that the dream state was not so different from the waking state. "We are in a dream," he said, and then, pointing at us, he said "WAKE UP!".

Hands:
THE HUMAN TOUCH

Fundamentally, human beings, whether Eastern or Western, need belief, free play of imagination and intuition in their homes and workshops or they become starved. All the cog-wheels and electronic brains cannot assuage these human needs in the long run. It is for lack of such essentials that we turn to dope of one kind or another, or to Destructiveness. Basically this (the Arts & Crafts Movement) is not so much a revolution against science as a seeking of a means of counterbalance by employing man's first tools, his own hands, for the expression of his inner nature.
—Bernard Leach

When I look at the wired-together skeleton in the studio or in the relic shop, I am always drawn to the hand. I pick it up, I hold it and turn it over, I touch the rhythms of its small forms, the fan of finger bones, and I think of the subtlety of movement that their design permits. Always one thing elicits my interest and that is the low placement of the thumb, which has its connection to the small bones of the wrist that the other fingers do not have. The thumb is able to face, to oppose the rest of the hand and therein is the superiority of human manual dexterity and our particular intelligence. The thumb is to the hand what consciousness is to the mind—a part that can look at the whole, reflect upon itself and interact with itself to enable a range of experiences and accomplishments otherwise impossible.

Deep inside Aurignacian caves are the hand prints of early artists, impressions created by blowing ground pigment through a tube onto the wall of the cave where the hand is pressed. The prints say, one after another, "I am here" and "I am here" and "I, too, am here." And in all times, the hand declares itself the master implement of all arts and crafts.

In Europe, the United States and Japan the industrial revolution of the nineteenth century gave rise to schools of handcraft as a response to the cold work of the machine. Today we have artists working in electronic media and these computer programs are truly amazing in terms of what one can do to create and manipulate visual imagery. It seems the only thing lacking in these media is the sense of touch and the spirit of the artist that can be felt seeing the work of the hand in pencil, ink or brush upon the creamy surface of paper, the planed smoothness of a wood panel, the play of hogshair upon stretched canvas, the smears and imprints in clay, the marks of the chisel in stone.

Though the technology is already available there is little building of three-dimensional form by computer plotting, but it will come into common use eventually. Such constructions will be made of three-dimensional pixels, identical components like tiny blocks. These pixels will be able to mimic the action of the hand, much like musical synthesizers can duplicate to a remarkable degree the sounds of various instruments, including the human voice. And although these compositions cannot rival the live performer and his spontaneous one-time-only transmission of feelings moving through a series of particular moments, this distinction will be lost as time goes by. Eventually, these

finer points will become the province of an educated elite of irrelevant connoisseurs.

But for now, look at your hand; consider its history and evolution and the millions who came before who have left us messages through the work of their hands, the perfect instruments of expression. Without using our hands to touch and shape things, to create and hold them, we are deprived of our natural physical way of manifesting our thoughts and feelings, of achieving something.

I have made tracings of my hands and filled these diagrams with pictures of all sorts of powers; flames, suns and stars, rainbows, the cosmos which pours through my hands. It is my remembrance and tribute to the body that has been given to me to make my way into the light. Head, heart, hands, all equal.

Now drop that mouse and pick up your pencil!

Pathways
HANDS ON

- Make a tracing of your hand, the one you use to write with, to draw with, and fill the tracing with whatever imagery you like. Draw in it, paint it, fill it with cut-outs or photographs of whatever you wish. What statement does the hand make?

- Make a print of your hand with ink, such as a stamp pad. Observe your fingerprints, the whorls and lines and the markings that belong to only one hand in the world. Can you find boxes, crosses, stars?

- Observe today how you use your hands as a part of your speech and self-expression, how they move through the air to

describe objects, impressions and actions, how they speak for you through gestures. Watch the hands of others for the ways they reveal unspoken thoughts and feelings.

- Look at the hands as they are represented in painting and sculpture, particularly religious works of all faiths—at the messages they bring, the similarity of Mudras in Indian, Buddhist and Pre-Columbian figures, and also in various traditions of dance. Feel the emotions aroused when the hands assume positions such as a fist, an open hand, a pointing finger, pressed together in prayer, reaching out, cupping water.

- For one day, be aware of everything your hands touch. What are you able to give and to receive through the touch of your hands? Be mindful of both sensation and emotion experienced through the hands and fingers. Watch a baby's hands.

- Touch the screen of your computer and observe the pressure of your fingers as an electromagnetic field.

- With eyes closed, pass your hands above and around various objects to sense their energy, shape, density and so on.

- How do people and animals respond to the touch of your hands? Can you feel the energy transmission? Is it something you want more of?

Part Two:

ART & MASTERY

Attention:
OBSERVATION AND PERCEPTION

Modes of attention we use in art are not unlike various practices of meditation. When we are working we are attending with all our being. Our work may involve visualization and representation of forms, mindfulness of an image, repetition, action without a goal, and so on. Without a formal practice the artist is a dedicated seeker. We may stand upon a platform of traditional training to reach our aspiration, but we move toward it in an intuitive way, rather than by strictly following rules, styles, or ideologies. Intuitive self-reliance is the way of the artist, and by faithfulness to our own vision we become a conduit for something beyond ourselves. We sense the beauty, the greatness of life and feel the beautiful and the great within ourselves expanding outward into the world.

In art we are training the faculty of observation, not through any forced exercise of concentration, but through our natural interest in forms and our desire to learn the skillful means of manifesting thought and feeling as art.

In drawing we use three modes of attention, and with practice we are able to use them almost simultaneously. These forms are **focused attention, open attention,** and **shifting attention.** Each is a way of thinking and looking when drawing from life and nature.

FOCUSED ATTENTION

Most learned forms of attention emphasize concentration, or focused attention. In order to concentrate, or focus, we attempt to exclude from our attention everything but a chosen object or image. We hold in our mind or eye this one thing and ignore or cast out invading thoughts, staying with the single object, image or purpose. This can be anything that has been selected from the infinite catalog of forms, such as a figure, a flower, a bowl of fruit. Studiously, we observe and learn the subject, yet after a time we may find ourselves at war with restlessness and prey to the natural urge to move and see things in relation to each other. In order to allow a fresh flow of information and energy, we alternate focused attention with open attention.

OPEN ATTENTION

This is continuous awareness of what is around us as the world and what is within us as our body, mind and feeling. With our attention open, we witness all that passes through our perception. All phenomena are free to assert themselves without calamity if we are not confined to the habits of thought we have inherited from our species, our family, our society. This is not easy because we need input from this museum of information just to get through the day. But in the protected space of the stu-

dio we can let a lot of it go. With our attention open we are aware without care, without "I-like" or "I-don't-like." We are just here; we are looking. Aimless, without a goal, we are an unbiased witness, whether of a still life of apples and oranges, of the breathing of the model, of the fear and worry in our mind, of the birds fluttering amongst the trees outside or of the curious happiness that intermittently lights up within us for no particular reason. To go to this state of open attention, we have only to remember to go there, to UNfocus, relaxing the mind from its task of study. While holding the subject before our eyes, we must enlarge our scope of awareness so that it includes not only the model but the room and all the objects in it, and beyond the room, the light as it moves through the trees outside, the sound of birdsong, the hum of traffic, the shush of the pencil on paper, the tick of a clock down the hall, the dream we had last night, the ones we love, our hopes and fears; all this without stopping drawing, but only dropping the focus, by which we have relaxed and expanded the scope of our senses. By returning consciously to the subject of the drawing, we have now obtained a new perspective.

SHIFTING ATTENTION

At the moment of obstruction and frustration, the shift to open attention will unconstrict the mind and its perception, and this flexing, this expansion gives us a fresh start. Sometimes all that is necessary is to pull the attention away from the extreme focus on a detail that is presenting the challenge, and to look again at the whole. If we are having some trouble with the anatomy of the model's foreshortened leg and we are trying to make sense

of that foot she's sitting on, the habitual tendency of the mind is to move in closer and closer to the tangle of forms. This prolonged kind of concentration will usually produce some very crabbed drawing: tight, overworked and unconvincing. Such a worrisome effort is the cue to shift attention to the whole form, working back to the troublesome detail from an area of strength. Thus, if we have mastered the torso, the hips, we move our attention from the strong lines back to the weak area, allowing a natural flow of forms. In this way our intuitive perception guides us where our conscious mind has burned out. Shifting attention—especially when we are most absorbed—is the key. Unplug the attention from a stale effort to inclusive awareness and back again to the detail. When conscious awareness is continually shifting from the whole to the part and from the part to the whole, an apparently constant stream of both perspectives begins to operate automatically. Mastering the troublesome detail in drawing is similar to the way a musician accomplishes a difficult passage. He does not stay with the passage itself, but begins with the body of work which has already been mastered, leading back into the difficult passage again and again in the context of the whole piece.

By practicing shifting attention we begin to experience several modalities at once. In art and beyond it, our reality is whatever modality with which we resonate and to which we consistently give our attention. Once we have given our attention to a particular realm of thought day after day, we become bound by the laws of that realm.

Continuously shifting attention requires some practice, but eventually it becomes a reflex. Then multiple perspectives

become automatic and the mind can hold two or more conscious points of view at once. The habit of shifting attention becomes a way of understanding all relationship. It teaches that liking and not liking are one mental movement and that the format of reality is not either/or but either/and.

Our happiness consists in having no wish for anything to be other than it is. It is not the world that needs to change, but our own view. What better way than humbly to draw, to try to see, things as they are in the world and in ourselves? Perhaps with enough time we will eventually see that, as we have been told, when we understand ourselves from every perspective we can examine the entire universe as existing within us.

Pathways
PAYING ATTENTION

- Practice drawing large circles with a brush. This has the effect of forcing two perspectives at once, because our action at any moment can only be on a small arc of the circle, and yet to have a true circle materialize, we have to hold in our mind a visualization of the whole. This is a practice that one can do forever, always improving the ability to be steady with the whole while we are active in a part.

 When you are able to draw the circle without hesitation, practice with other simple shapes—an equilateral triangle, a square, a five-pointed star.

- On a large sheet of paper begin drawing an object in your immediate environment. Draw this subject at the center or slightly off-center on the page. Now, continue by adding whatever you see that touches on, surrounds or overlaps the subject. Use a pen or brush-pen so that you will draw with some immediacy and not fuss. Fill the entire space around your subject until there is no empty paper. Observe your observations. Looking at the object with which you began your study, how do you see it differently now that it is located in a matrix? If you drew it again in isolation, how would your perception be altered?

- Select a subject to draw and place it close to the center of your drawing surface. Consider it as the center of the universe, seeing beyond it, the walls that surround it, the room, the street, up to the sun and moon. Find a way to bring the entire cosmos as you conceive it into the picture. Don't concern yourself with literal representation, allow metaphors to enter as you wish. Try this with a self-portrait.

- Drawing the figure, think of the whole body as you work on the small forms. When observing a hand, for example, try to see the other hand in your peripheral vision, as well as the head and the entire body. Remember to shift attention from the detail continuously to the whole, seeing the relationships amongst all the parts at all times. Look for parallel lines, matching circles and spheres, orbs, cylinders, boxes.

- Remember that as you sit and read, you are a dot on an enormous sphere that is hurtling through space.

Seeing:
LIGHT, THE EYE AND THE MIND

*The essence of the question involved here is contained in the
saying of Plotinus that the eye would not be able to see the sun
if, in a manner, it were not itself a Sun. Given that the sun is
the source of light and that light is symbolic of the intelligence
and of the spirit, then the process of seeing represents a
spiritual act and symbolizes understanding.*
—J. E. Cirlot

The mechanism of seeing has not always been regarded as it is
today. It was thought as recently as the seventeenth century
that the eyes sent forth a light of their own, which fell upon the
objects of observation and transmitted their appearance back
to the mind. It was postulated that some vital substance origi-
nated in the observer, which in a sense we now know to be
true. For even though it is thought, not light, that shapes our
conscious perception, it is also true that something goes out
from the observer that affects the thing seen. This is known to
every artist and model, and to every nature painter. One feels
the response of the object in the studies of Durer and Millet; in
a lonely corner of a garden a dewdrop, a few blades of grass are

glorified, being seen. The blue sheen that shoots across the wing of a dead bird is a living message; something is happening that can only happen because there is an observer. Seeing into the object, I am merged with it, attuned to it, I am, in fact, identical to it. Through unclouded observation, the separation of the observer from the observed is overcome. I don't mean to say that I think I *am* the thing, but that I feel something, I touch and am touched, I lose my boundaries and merge. I not only perceive the object, but most amazingly, **the object itself is altered in being seen.** This interaction happens mostly at an unconscious level and if it were not for the dominance of the rational mind, this flow of energy would be universally acknowledged and understood. As the mind is always attempting to pigeonhole and classify information, it is somewhat opposed to the experience of this moment. The mind is much more comfortable and in control in the past and the future. Yet the spirit knows only the present, only what is! Most of the time I feel as if the world is more real, more absolute and enduring than I am, but when I am attentive and thought is upstaged by a cloud or a hummingbird, I always experience the sensation that not only do I see, but I am also seen; something in the object is aware of me. We are in it together, the model and I, the bird and I, the brass bowl, the bunch of grapes and I. My active perceiving is like a being in itself. It is something living, which I could understand and liberate if I could escape thought.

The act of seeing is the only truth.
—J. Krishnamurti

IN THE STUDIO

The saying "Seeing is believing" should be turned around to read "Believing is seeing" because what we believe and expect to see is indeed what we do see. The difficulty in drawing from life is caused by habits of thought and perception. Drawing a complex subject such as the hand illustrates how knowledge and direct observation open up vision. We may have a vague idea of the hand as a kind of block from which five little cylinders extend. The emergence of the thumb right out of the wrist bones is something usually not represented, because this fact has never been noticed by or pointed out to us. Until we have understood the anatomy of the hand, the work will not feel right—will not feel truthful. Seeing and drawing the skeleton, looking at X-rays and endlessly drawing the hand will give our work strength and conviction. After these studies, we will remember that the arc of the fingertips is longest at the middle finger, that all the finger joints and knuckles follow that fan-like pattern. We can prove this by closing the hand into a fist. Once this constant is understood, it will be seen as a repeating rhythm that can guide us no matter what position the hand may take. After much study and attention to the work of masters, we gradually come to understand the intricate and subtle forms of the hand and begin to render it without the halting and inept lines that are the result merely of ignorance. In every case it is unbiased observation—seeing—that develops abilities in drawing.

Some students habitually draw the feet too small. I like to point out that, on the average, a person's foot is the same length as their inner arm from wrist to elbow. Once this new and, to many, surprising proportion is observed, the artist actu-

ally sees the foot differently, and will now render it according to the realization.

The correction for the very common misperception of the shape of the head seen in profile is the viewing of a real skull. Drawing a profile, many people look only at the face, laboring long to satisfy their sense of verisimilitude. Yet the salient factors of a portrait have more to do with the set of the head, neck and shoulders than the area from brow to chin. A quite recognizable portrait of a person can be created without drawing the face at all, if the character of the upper body has been captured.

The novice often flattens the back of the head, ignoring half the brain case. When the skull is turned upside down, we can see that the hole where the spinal cord enters the head is near the middle of the bottom of the skull, the brain case extending far back beyond the spinal opening. Skull in hand, we see that knowledge informs seeing—knowledge or the lack of it.

The artist draws everything in order to grasp its nature. Drawing is itself a form of seeing. The attention of drawing is open to unpredictable relationships of forms in space. If the drawing is unconvincing, the mind has not grasped the form. This is not to say that art must be realistic or even representational, but that we must pass through the visual apprenticeship before being able to legitimately disregard knowledge. I suppose when full mastery in life is attained, one does throw out the accumulated practices, but this is because they have led the artist to a new ability, which is to live naturally, innocently and to paint as birds sing—to flow with inner and outer nature. This level of ability no longer needs practices. But to get to this point through skill is different than to attempt the journey without it.

From a pattern of light falling upon the retina and interpreted by a particular receiving organism, we have Rembrandt, Da Vinci, Vermeer, Manet, Goya, Van Gogh, you and me, whose gaze and vision transform the world.

Pathways

VISUAL APPROACH

Looking around us, our acuity of sight is greatly enhanced if we refrain from mentally identifying what we see. Instead of the ocean and sky with clouds, we observe a horizontal division of two masses of variously colored tones of blue, green, gray, etc., the upper portion interrupted by irregularly shaped forms of lighter or darker hues.

- To break the habit of calling the subjects by their names, to see with a sense of newness and surprise, we can try viewing things in a mirror, turning our head upside down, looking through colored or faceted lenses, crossing our eyes, looking through a hole in a piece of paper, twirling, or any other innovation of forming visual impressions that comes to our mind.

- A powerful tool in allowing newness of vision is gazing. Just staring into a scene or at an object will divest it of its conventional identity.

- When drawing any object, learn all you can about it. Research its form, history, constituents, then approach it with knowledge to guide you. We draw the tree from the ground up, but if we understand the hidden part, the root system, our tree will be more convincing in the way we feel it rising up from the ground. The tree does not begin at the earth line. Nothing begins where it seems; everything grows out of something that supports it. To know the surface, look beneath the surface.

- Be still amidst movement, move within stillness.

- To develop attention, observe yourself while drawing or otherwise using attention. Be aware when you become inattentive. You have become inattentive, but you do not have to make a conscious effort to return to the state of attention, for if you do, you will set up a condition of conflict, and inevitably, resistance. Simply being attentive to the fact that you have become inattentive is all you have to do. Seeing clearly arises out of interest, not discipline.

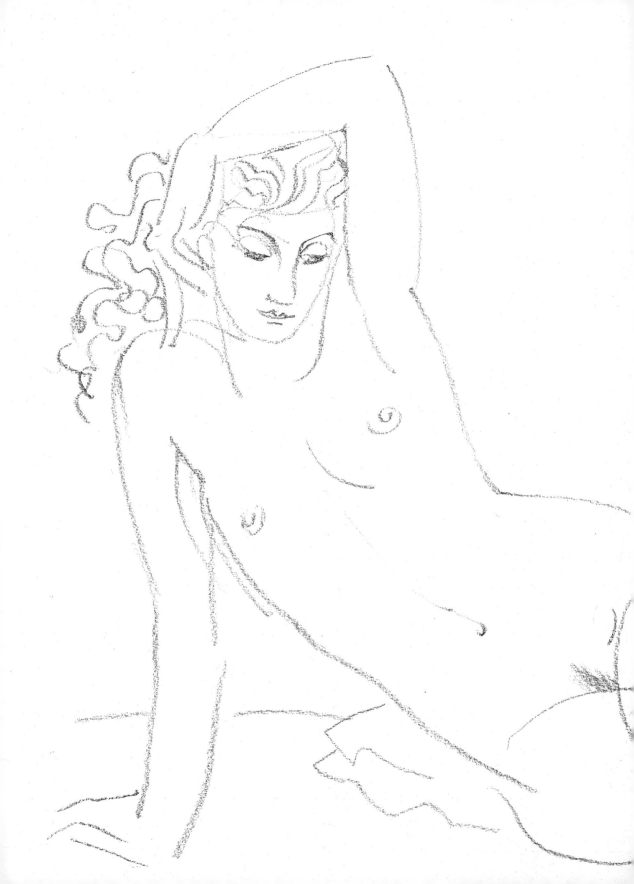

Nudes:
DRAWING FROM LIFE

*There is nothing in all the world more beautiful or significant
of the laws of the universe than the nude human body.*
—Robert Henri

Who am I? I look into the mirror and ask the question, who am I? The mirror answers with the human image: I am this face, these eyes looking out, this body. The body is not a symbol for me; I exist in, through and around it. It is the form of myself which I and others can see and touch. My eyes fill with the radiant colors and forms of the world, the eyes of others meeting my own, our unspoken disclosures—all happens in this body, in the dome of this head. Angels and demons meet in the dusty light of this tiny cathedral where spirit and matter entwine.

We are standing before the model, pencil in hand. We are looking. Soft light falls on a lithe figure, the curves and angles, the impression of line where the edges of the forms meet the space surrounding them, the small arabesques of lips, eyelashes, the swirl of the hair. Before we can make the first stroke, countless thought connections have been sparked; these influence how we feel about what we see. These thoughts and feelings may lurk in the subconscious but they come out in our touch; in the way we handle the pencil, our suppleness or rigidity, the pressure and movement. We do not need to consciously project our feeling. In this practice we can lose ourselves in the ever-deepening contemplation of form; then feeling itself can act, and we experience and witness the emotive power as it gathers through a succession of moments. We are the instrument.

Drawings and paintings become "things" when they are finished with the artist. But before they become things, they are a movement of the self through time. For the artist, as for the musician, the creative act exists dynamically in time.

Eternity is in love with the productions of Time.
—William Blake

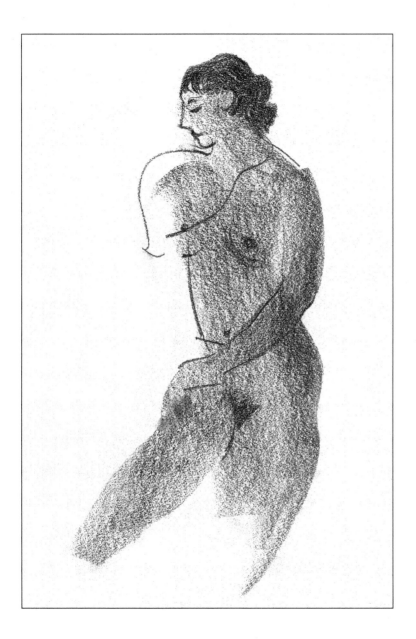

Our audience, accustomed to viewing thousands of pictures and electronic images daily, has lost the opportunity to linger before a work of art, seeing into it further than the first glance can go; and we need time to look, because the work took place

over time, whether in a minute or over a month. In figure draw-
ing the temporal process is particularly on display because of
the directness of the medium, and because we must hurry to
capture the form, to learn the ways of knees and shoulder blades
before the pose is broken. Wordless conscious attention is given
to analyzing the relationships of the forms, the rhythms of the
masses, the space, the light. We are searching out the truth about
the subject at this particular moment in time that we are sharing
with that subject. And as we move the pencil around over the
surface of the paper, our eyes are touching our subject, entering
it in ways we are never aware of. We see and draw at the same
time. What we feel and think is forming, appearing from second
to second. Through this attention the mind is led away from the
automatic, the preconceived, the I-am, I-want; out of deep inter-
est in the subject the mind abandons its unending loop of habit-

ual thought that clouds perception. Open-
ing to the model, I am entering a universe
in which I am conjoined with another per-
son, body and soul. Now comes a merciful
suspension of the charging ego-beast, if
only momentarily.

Looking, merely looking, eyes and
mind are one.

We think of our eyes as receptors of
information that is then transferred to the
brain, but actually the eyes are a *part* of
the brain—they are its lenses sent forth on
filaments of nerves to meet with the light.
The "seeing" of drawing is a unique per-

ceptive function. As we draw, we see and feel in a way that is unlike our thinking and feeling in any other activity. Drawing from life frees us from the locked room of thought, liberating new abilities. With each pose one makes discoveries, because the mind of the artist in this practice is the quintessence of "I don't know." Resting in not-knowing, I am open; all my faculties are available. The subject, the sight of the subject, the process of perception, the search for form, the belief system, the unconscious drive, the subconscious motive, the conscious analysis; all merge in one movement, emerge in one line, and where perception has been untrammeled, truth may be found.

We make our best effort to represent an objective truth, but the truth we represent in the end is the truth of the artist. This transmission of spirit through its activities is the source of the whole visible universe. That is why we are happy in our work; we are elevated by the creative and released from our confinement.

When I have mastered the skills of my art, my drawing spontaneously comes alive. The glance of the soulful human goes through me as if I were a lens, the light emerging out of my pencil or brush or graver. While I occupy my conscious mind with measurement and proportion, a superconscious self is drawing

and painting. Now I am using the mind as a tool while my soul can dream, free to be present with another being, another pair of eyes. All the time I am responding: what beauty! How perfect the gushing hair or the supple torso. Now I see into the body, feel the spring or drag of muscles, revealed by a tenderly diffused north light. I see the ruddy skin of Karen, who says she is eating too many carrots; who shaves her pubic hair into an oval. Sherri, petite and curvy, is a delicate exhibitionist; a dancer who likes to take poses from the erotic drawings of Rodin. Eric, a powerfully muscled young man, doesn't pose well but his body speaks on its own, the burnt umber of his skin has blue in the highlights, purple nipples. Kele, a Pre-Raphaelite sylph, has flaming hair and a boyish slenderness. Stephanie's eyes are large and liquid, her body has a casual grace and creamy radiance. Greg, who hadn't posed before, self-consciously discovers the pleasure of exhibiting himself. Katy, pretty, flirtatious and fat, with tiny feet and pleading eyes, likes to wear hats.

Their arms extend as if to gather in or to give away, their hands close to grasp or open to touch. Torsos swell toward me or fold away, the sexual parts with their lure, the legs and feet holding us upright, taking us where? The amazing moving architecture without a site, its foundation anywhere. All the glinting, heightening and fading changes, the beauty of the late afternoon light and of the body as it opens, expands, reaches its fullest and fades back again, the shadows entering faintly, then tumbling across the scene, then the dark.

If every atom in existence is alive and reaching out, the human body is more than we can know. Here we stand in it and before it; flesh, our dress and diagram.

Pathways
LIFE DRAWING

- Today, draw from life—your own face or hands or feet, your friend or lover. Use pencil or charcoal. Do not use ink or markers except occasionally. Stay with the pencil work until you have gained fluidity. Use erasure and smearing of the line as well as hatching for depth and tone.

- Have the subject pose still and moving back and forth. Draw a series of movements as you capture them.

- In a dim room with the lights out, set a spotlight at the side of the subject. Observe the continuous shape of light or the shadow. Draw the shape of the light and shadow as if it were a piece of fabric draped over the figure.

- Draw the mass of the figure without using line. Use the side of a woodless pencil or a stick or charcoal or chalk. Or brush a wash of ink in the general shape and add line afterward.

- Remember to use the drawing session for studies of hands, knees, etc.

- Read the great writers on figure drawing: Bridgeman, Robert Beverly Hale, Da Vinci, etc. Attend classes on artistic anatomy, learn to identify the bones and major muscle groups.

- Take the model to dinner.

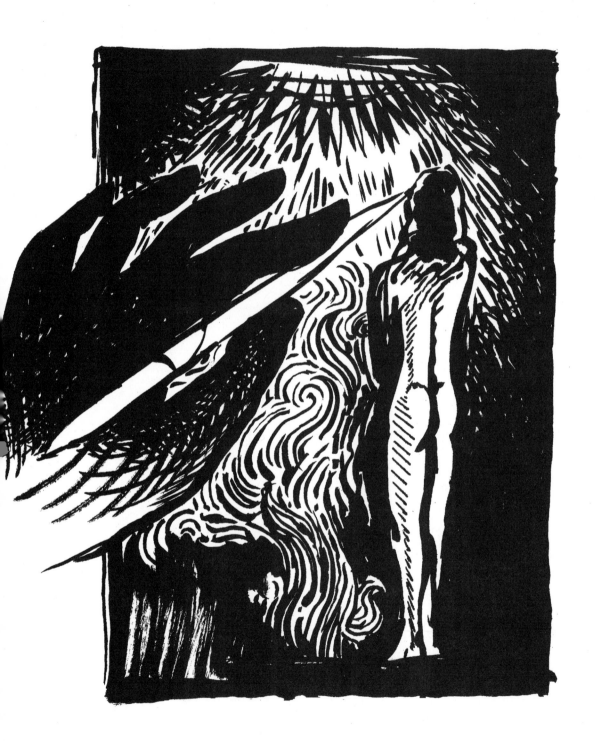

Style:
WHAT HAS NEVER BEEN

So we see that a deliberate search for personality and "style" is not only impossible, but comparatively unimportant. The close relationship of art throughout the ages, is not a relationship in outward form but in inner meaning. And therefore the talk of schools, of lines of "development" of "principles of art", etc., is based on mis-understanding and can only lead to confusion.
—Wasily Kandinsky

The artist works, and the accumulation of acts prompted by perception and necessity gives rise to a certain look in the work. The painter may one moment squeeze paint directly onto the canvas, needing that gelid purity of color just there, just then, or she may have a flourishing gesture or a staccato brush or love a large field of unbroken color; any number of idiosyncrasies develop where there is freedom. The artist's work may be seen as radical in its own day, and in the future it will be found to be exactly the expression of its time and place and manner. Often in the arts, after the golden age of just-becoming, a style is named by its practitioners and valued for its own sake. This attention to style gives the impression that a style, a formalism, is innovative when it is really only a variation. The true style is

that which evolves out of the artist's needs and impulses. It is not separate from the content, which is known only through this materialization.

> *It is impossible to detach the form from the idea, for the idea only exists by virtue of the form.* —Gustave Flaubert

Style is not a primary concern of the artist who is motivated by necessity, but that artist will, over time, develop a distinct and recognizable way of handling the components of his art. Just as we do not set out to communicate but to experience, and yet we do end up communicating; so in setting out to capture a sensation or vision, we incubate a style. Because if you are following your instinct, your style is the result of that movement and not merely something you have invented for its own sake.

> *The painter who has found his technique does not interest me. He gets up every morning without passion; calm and peaceful, he continues the work he began the day before. I suspect he feels a certain boredom peculiar to a virtuous worker who continues his task without the unforeseen flash of the happy moment. He has not the sacred torment whose source is in the unconscious and the unknown; he expects nothing of what will come. I love what has never been.*
> —Odilon Redon

Sometimes style is adorned with the subtlest skills, as in Leonardo's *sfumato*, the glassy brushwork of Vermeer, the elegant line of Ingres. Just as often it comes out of inelegant inner struggle as in the work of Van Gogh or Soutine or Kokoschka. We may admire the resulting style, we may even be inspired to emulate it, but in order to receive what the artist has to give us we have to be open to the entire movement of his or her being

in the work, beyond the surface appearance. To penetrate the surface, slow down, stand before the work and let it speak to you. To open your comprehending heart be quietly receptive. Time, take time. As the whirling mind comes to rest upon the visual field before it, the action of the artist guides your attention away from the claustrophobic inner monologue.

If you look without judgment, which is the ideal way, ideas and feelings will come streaming out at you. Attention without judgment is attention without conflict. Rather than the habitual response of liking or not-liking, extending time for observation shows us the forces at work. What is this? What do I feel? are more productive questions than "Do I like it?"

Live and work out of love, attention and necessity and the form will take care of itself. Do not even give it a thought.

Pathways
REVEALING MEANING

- To discover your own natural style, expose yourself to the style of others. See how the same subject is approached in an infinite number of ways. Look at representation, subject by subject to grasp the endlessness of possibilities. For example, the human face by Giotto, Da Vinci, Botticelli, Gruenwald, Rembrandt, Hals, Gainsborough, Fragonard, Manet, Picasso, Matisse, Jawlensky, etc.

- Do not fail to try every medium. The different media give rise to distinct elements of style for every artist. Experiment with every tool, all drawing and paint media, printmaking, collage. You may find that certain elements of your artistic personality emerge consistently in particular media.

- Observe how cultural values evolve or favor certain styles.

- Look at art that moves you: what are the common elements, colors, qualities of movement or stability, what is the emotional tone that attracts you, is it classic or romantic in nature, Apollonian or Dionysian?

- Is it crude or sophisticated, trained or naive?

- To arrive at your own particular way, render a simple subject over and over again in various media and scale.

CHAPTER 18

Self:

BEING WHO WE ARE

Is it possible to be completely myself in every circumstance of my life and art? In the daily struggle I question myself about my true feelings and the direction of my life. Yet in my art, in one line I am completely myself immediately through action that is not circumscribed by thought. In the movement of art I am as close to my origin as a fish is to water. The fish is made of water, lives and moves and has its being in water, enjoys its life in water, and returns to water. The fish doesn't say, "I must attain to the sea. If I were self-realized I could know the sea." Because no one knows the sea better than the fish, although it doesn't know that it knows and doesn't need to know that it knows.

Schools, sects and religions are often vehicles for personalities and ambitions. Tread cautiously there. Why talk of enlightenment, what one must and must not do? Imagine someone who experiences perfect awareness giving much gravity to ideas of must and must not.

Living appropriately moment to moment is our only hope, the only way to be true human artists. Postulating and giving rules to ourselves—these precepts and prohibitions only take us farther away from the goal. Thought can't get there, though it comes close, very close. Yet in the end we have to go beyond thought—its domain is too limited to encompass What Is.

To know ourselves we must find a way to defy the clamor of all we have been taught so that we may be truly instructed—by a bird, a baby, a tree or star. And if we are faithful to these teachings and carry them with us always, we are fortified against the delusions that support our social order. We can still live in the midst of the world, enjoying its accumulated knowledge and technologies. But as we embrace the innocent silence within us,

forgoing the noise and constant company of others, the controls relax and the flower of our spirit can open and bloom. We need space, space to feel, space to express, space to sense the order of things in the natural world.

The major block to being ourselves is the dread of solitude. Even a person living in the remotest forest can be linked constantly to others via technology; the loneliest people are in constant virtual contact with others.

Be fearless and be alone. BE ALONE! It may be frightening at first, but if you continue, see how your self becomes a refuge. Letting go the need for continuous contact, stressful and pointless talk, meaningless comings and goings, amusements and entertainments created for profit. **Be alone and be silent, looking and listening, touching and remembering, breathing in and out.** This is enough to grow on, and if we should take up our pencil or brush in this state we shall have found a road to happiness, a map to our own nature and capacities. We will never receive from another what we have to learn for ourselves.

To know our mind—two things:

First, willingness to be with ourselves alone. Alone in quietness—in this space, the inner life can expand, for it is hemmed in and stifled by all the cacophony pressing in on us. Go on past the first responses of boredom and panic and see what arrives. No rules, sitting or not sitting. No practices, move only upon the desire. Wander. Look. Listen. Breathe. Imagine the earth without us.

Secondly, willingness to act when prompted by insight, impulse or imagination. Thinking about doing does nothing.

Nothing we can conceive matches what comes when we are actually working—the dynamic is not the same. Thinking of painting is not contributing to painting at all. In fact, the mind busies itself with so much embroidering of the idea, the truth is that it is much easier to paint than to think about it!

I can be alone with myself. The strangeness I feel is just the unfamiliar sensation of my self.

Once we have become accustomed to solitude, we may not work anyway! Inside each of us there are conflicting impulses. There is the creative impulse, which enjoys materializing energy, and there is a **contemplative** impulse, which enjoys not making anything, and which prefers **not** to dedicate itself to any purpose in particular.

Instead of feeling guilt and a sense of shame about a period of nonproductiveness, why not just attribute this to the dominance, for a period of time, of the receptive, the passive, the idle mind?

It is sure to be stirred into activity eventually, since change is inevitable. Unless, of course, you focus intensely upon the PROBLEM, in which case, just as in overworking a part of a drawing, vital energy is lost and the mind simply goes mad over its inability to control the creative. So, forcing yourself to work doesn't work! And neither do the various formulas for whipping up your creativity. They work for a while, until you grow tired of the routine, at odds with yourself, and with a new case against yourself. Leave yourself alone! When you can't work, why not just say, "Thanatos has got me today. May Eros rescue me tomorrow."?

A PERSONAL DIRECTION IN ART

We begin as children with a box of beautiful, pointed crayons

and undistorted observational skills, and we select our subjects without inhibition. But as we become socialized, the introspective tendency is overwhelmed by the group identity. Still, children love to draw. By the age of ten or eleven, they have been exposed to art in some form or another and they begin to have a desire to learn techniques they admire in the works they have seen, whether these works appear in the Sunday comics or in paintings in museums. Children of eleven or twelve are attracted to realism. They now want to know three-dimensional rendering and perspective. In our educational system, with its societal, political and economic priorities, this wish is simply not addressed. Art in this system has become an archaic and irrelevant value. So most of the children become discouraged with their efforts and drop their art altogether.

Many of my students are those who turned to art again in maturity, picking up where a twelve-year-old left off. But even for those whose gifts have guided them continuously, there comes the time when, after experimenting with media and theories, they want to focus upon and develop the personal direction that makes the most of their abilities and insights. When gifts of insight merge with gifts of mastery—art!

Rembrandt and Shakespeare did not live as they did in order to fulfill an ambition for greatness, but to answer their need for truth. Both men were aware of the profundity of their gifts and of the relatively unevolved consciousness of the public they served. They were completely devoted to the power of art, paint, poetry and drama. They were enjoying their gifts, pouring forth works one after another over long periods of time, being themselves.

Approaching a new student, I see she has drawn the figure in bold simple strokes of charcoal, reminiscent of Leger. But before I can say a word of praise, she apologizes, "Oh, I have such a heavy hand. I have to learn to draw more lightly." By opposing our own nature we will never realize ourselves. We have to accept ourselves, and seizing what powers we do have, persevere toward our goal—mastery, freedom, on our own.

And so, what is our own? Our body, our memory, our own particular way of seeing, feeling and thinking—our affinities for form, line and color are unique, our dreams and all our idiosyncrasies are the fuel of art and merge with the great themes that have lured and challenged artists of all times. Not what it looks like, but where it takes us. Oddly, in the end, what is uniquely our own is found to belong to us all.

Pathways

BE YOURSELF

WHAT ARTIST?

- You only need to gather some of your works on a wall to see the artist behind them. The recurring motifs tell us of the artists' conscious purposes. The unconscious purposes come through the handwriting, the surface of strokes and daubs, the scale, the qualities of light and dark, the marks that make up the painting, which are not so much about the subject but are the revelation of the mind of the artist.

- To understand yourself as an artist you must first have produced a body of work in various media, though even a scant oeuvre will reveal what is essential. Looking at this body of work you can see the dominant direction of your efforts. As you look at these pictures, ask, "What is the content?"

- What objects, forms, beings, are in the pictures? Is it landscape?

- Inscape?

- What is the prevailing symbolism? What is the overall mood?

- How do the strongest works relate to each other?

- Is there a common thread? Your work is a mirror. Your work is you, both essentially and potentially. Some artists have an obvious affinity for line, others for shape and composition. There are colorists and illusionists. Look for the direction that has already asserted itself by your hand, so that you may follow your innate desire and keep moving in the direction that is calling you. This is your art, and this body of work is a subtle body you can point to and say, There I Am.

Expectation:
DISMANTLING ARTIST'S BLOCK

Heaven and earth are out of communion and all things are benumbed.
—I Ching

What is the mechanism of artist's block? A desire or a thought arises to do something. It seems that as soon as the desire arises, the mind explores a multitude of considerations and reasons not to do something. Why is this?

If we accept the duality of all that exists in the mind, we see the indwelling urges of both the active/creative aspect of our mind and the passive/thanatopic (death-attracted) force. Like the salmon, we must use our life force to propel us against this natural and unending current of dissolution. It is no small matter to take pen or brush in hand and challenge entropy. To care. When this caring becomes constant and intense, the descending current is overcome by the rising of the creative power.

But if sometimes I don't care—I sink. I need not feel this withdrawal from the creative as a calamity. It is not a fault or a threat to the quality of my existence, causing me to fall short of my potential, my goals and aspirations. I can see the block as the natural downward spiral, expressing itself in me at this moment. Pitched against the creative drive, the downward movement causes stasis, in which the two conflicting currents cancel each other out. Nothing destructive is happening, in fact destruction is not the opposite of creation, for destroying has a motive force and expression of its own which can be of great formative value. The opposite of the creative impulse is this downward spiral into emotional shutdown. Shutdown, stagnation, standstill.

Once I recognize the downward pull as a natural force, I am free of personal responsibility for the block. This freedom from identification with the condition of stagnation clears the way for new movement. Nevertheless, the block may not dissolve itself without some effort on my part to reconnect with the movement of the creative. How can I do it? It's a bit tricky, like jumping onto a moving train.

My attempts to overcome the block must address the difficulty of beginning. If I can release myself from the pressure of my expectation, that is enough to break the deadlock. If in a moment of indulgent repose I see the moon, hear the song of a mockingbird, think of the arched neck of a horse, the face of a sleeping baby, a flock of geese, a heron feeding, if I listen to music I love, read Rilke, see something, anything, with clarity, in front of me or in memory, I have become enthralled by life. And, by not attempting to use life to create art, I am released from my ego-driven concern about being an artist and making art. I have let myself fall in love again with something, anything, for its own sake, and in this spirit I may just pick up a pencil or brush. This is the easy way to break the block and it is also a gift and cannot be ordered. Once I have made even the slightest stroke, the block is over. New or unfamiliar materials, models or workshops can help. But if you use a system, you will eventually leave it. Don't confine yourself to a system, but search for the way back out of systems and into the spontaneous light of life. Stop thinking about art and live! Thinking about working is not working.

You are the teacher and you are the pupil.
—J. Krishnamurti

Pathways
DISSOLVING RESISTANCE

- One way of breaking a dormant cycle is to be one's own apprentice. Since the critical factor of beginning is to have at hand the work materials, do this disinterestedly, putting out the canvas, the paints, solvents, mediums, rags, everything the artist may need. Lay out the brushes and make everything available, with NO intention of working. You are simply preparing the studio for the artist. Eventually the artist will walk by and pick up the tool, going to work automatically. If the artist doesn't begin working and the paint dries up, simply squeeze out fresh color. This doesn't usually last more than a few days or a week until you have made it so easy that your natural interest causes you to begin. Where procrastination and negativity reign, this is the easy way. The artist is a

mental drifter, like water always seeking the lowest level of effort, of resistance, hoping to flow into the new work rather than to fight her way there. Occasionally, great bursts of energy rise up and we return by effort to the source and spawn something new.

- Relax and let time go by. Waste time before it wastes you. Once your palette and brushes are in formation, your clay or camera, just leave it there. If the apprentice has been vigilant, one time when you are walking by, you will do it. Once you begin, you are free. And if you never begin, you are still free! After all, we are such limited beings, our greatest art cannot match the art of life itself.

- If you are concerned about not working, wait six weeks and then forget about it. If you are inactive and not producing, let yourself turn away from the need to produce. Cultivate the receptive part of your nature by looking and listening—looking at yourself, at nature, at the work of others. It's pointless to FORCE yourself to work; that is so opposed to the spirit of art. Your job now is to relax and open, however you can find a way:

Read

Listen to music you love

Go to concerts and performances

Attend exhibitions

See someone you've been missing

Gaze at the stains on a wall

Read a book you enjoyed as a child

Collect junk and objects you find, without
 planning to make anything of them

Plant a seed and watch it grow

Be thankful for the good things in your life

Expand this list

Self-Portrait:
THE FACE IN THE MIRROR

As we still do not know what this self really is, this self in which you and I in our various ways are expressed, we must peer deeper and deeper into its discovery. For the self is the great veiled mystery of the world....What are you?
—Max Beckmann

Numerous artists are known for their self-portraits, and all artists have done them, sometimes because we are our most available model, but more often to touch some truth about our own being. To see ourselves. Some artists have left veritable visual journals of their faces from youth to old age. Rembrandt created over ninety self-images. Max Beckmann left about eighty as drawings, prints and paintings, over a period of fifty years, beginning when he was fifteen. Botticelli put his own portrait into his *Adoration of the Magi.* Caravaggio painted his face on the severed head of Goliath. Ensor etched his likeness as a dilapidated skeleton. Almost the entire oeuvre of Frida Kahlo is self-portraits. Durer, Samuel Palmer, Goya, Munch, Picasso, the list goes on. No artist can resist the face in the mirror.

The lure of this method of self-discovery also extends to artists whose primary discipline is nonvisual. The poet E. E. Cummings painted himself throughout his lifetime. Jean Cocteau drew himself during periods of recovery from opium addiction. A painting by George Gershwin shows him in front of a sheet of music. Bob Dylan attempted a self-portrait for the cover of an album entitled *Self-Portrait.* Jerry Garcia presented himself in various guises in both ink and watercolor; an etching entitled *How Fine* is a self-representation in a certain frame of mind.

The self-portrait transports the artist into a condition of uncensored self-indulgence, fantasy, glorification, compensation, confrontation or penitence.

In this work we are not only our self-image, endowed with particular traits, replete with qualities we know and recognize as ourselves; we also see as we look out from the mirror (the supreme metaphor for self-reflection), a stranger. A new person

appears whom, without this exercise or trick of art, we should never see. It is an act of self-revelation unlike any other. Painting ourselves, we can love ourselves, literally at arm's length. Here is someone unlike any other person alive—this is myself.

A few qualities are common to almost all self-portraits. For one thing, since it is done before a mirror, the gaze will usually fall directly upon the viewer—the subject looks right into our eyes. The artist may present with a brooding or a piercing look, he may show many moods from conceit to humility, but the self-portrait always loves the sitter. Do it.

Pathways
DRAWING YOURSELF

- An interesting project and one that will meet with little resistance is to keep, for a time such as a month, a daily sketch of oneself. Using simple materials—a pencil or brush-pen, a crayon—give it twenty minutes to an hour, not longer, or it may lose the spontaneity and become a chore.

- Keep it lively; just try to capture whatever it is that is the "me." When you're satisfied that you are in it, stop and put away your sketchbook. A project through time can become ponderous if we try too hard. Enjoy it. Allow yourself to represent your image with realism, fantasy, surrealism, symbolism.

- Rembrandt made self-portraits in outlandish costumes, medals and plumes. Bring out your moods and qualities as they present themselves and don't worry about how others may respond to this work. The thing to be learned is self-perception, and the repetition of the subject daily over a period of time is very revealing. Make sure that you date the drawings. When you have made twenty or thirty, put them away for a while. Later when you bring them out, you will feel newly acquainted with yourself. So who are you?

- From a photograph of yourself as a child, draw yourself as you felt when the picture was taken.

- Draw yourself nude.

- Draw yourself in profile by setting up two mirrors. What do you feel presented with this unfamiliar view?

Action:

A MOVEMENT OF THE MIND IN TIME

I am the slave who set the master free,
I am the one who taught the teacher.
—Jalal al-Din Rumi

What do we mean by "a total movement of the mind in time?"

If we observe the activity of our mind over a single day, we see an endless procession of thoughts; we think about what we have just done and what we will do next, we brood over our appearance and what we will say or should have said to a friend, our progress with money or our lack of money, our hopes and fears, our fantasies, ambitions and regrets.

In order to live in this world we have created, we run from one pointless activity to another, captives of our own thoughts, proving and measuring ourselves constantly against others. Our efforts in our work become stifled, controlled by the laws of the marketplace. Pressured to abandon our gifts and goals, we give in to seeking acceptance through conformity. We are not available to ourselves for any experience as a totality, because our mind is tormented and distracted.

Wanting love and wholeness, we miss every opportunity to experience it because we are obsessed with self-evaluation. In our need to rise, to succeed, we are like litigants in a case against ourselves in which the jury is always out, and we can never rest from one moment to the next, because of the ceaseless deliberation over our fate. If we are acquitted we shall be found to exist and to deserve esteem. If, on the other hand, we are found wanting, we shall certainly face annihilation, and our ego suffers in this way all day every day. The vulnerable ego, endlessly self-considering, is a pathetic puppet that renders our whole life a shadow play, instead of the procession of glory it was meant to be. Preoccupation with the status of our ego is the cause of the fragmentation that prevents us from entering the stream of life.

What we want is the whole mind one-pointed and aware, so we may reclaim the depth and the nobility of our nature and follow the true direction of our life. We want to live up to the promise of life we once felt, and to end the trivialization. If we are fortunate enough to find a great and abiding interest in something beyond ourselves, that gift has the power to lift us above the negativity and obsessiveness. Yet we have to honor the gift, to find soil for it to grow in, to devote ourselves to its ripening in order to experience the full extent of its possibilities.

People have studied the mind for thousands of years and offered many methods for getting it under control. But what if we have no school, no method, indeed, no conscious understanding of our dilemma? Is it possible that through a gift we have been born with, through our artistic and creative instinct, we can overcome the limitations of the fragmented mind? We can.

This gift, if we obey it, is a vessel upon which we can sail into a timeless ocean of creative movement, all fragments on board together, speechlessly joined in the current of life, which is the NOW. Because of our attraction, our love of an art, we can become free of the small mind. Our art is our book and our redeemer.

Some systems of thought propose clearing away the debris of the ego in order to reclaim the immaculate mind of the true inner self. No doubt many lifetimes are spent in this honorable pursuit. But it is possible also to make progress in the midst of obstacles by taking an instinctive and visionary perspective, and to gain self-knowledge on our own, seeing things as they really are.

Such a train of thought guides the artist's activity as she

works. My stream of consciousness runs like an underground rivulet as I paint in my garden:

In this garden I sense the relatedness of all creatures alive today. The lemons hang from their weary boughs, drooping in radiant clusters above a black and white dog, drowsing disappointed, locked out in the yard. Why are we in this place together? An answer comes as the fatefulness of every meeting and each being in our lives. It is so uncanny as to seem plotted, played in costumes such as tree, dog, painter, disappointedness; appearances that color the air and dissolve boundaries, merging into a one-time-only self. I am the artist, supposedly unique, and yet what is unique seems at this instant so trivial, so absurdly limited, a quirk which will not be missed, only a tool for experience, a vehicle for this—feeling. Step lightly, a voice says, you are the actor, this feeling is taking us forward, we are a doorway for a force beyond things to rush in and direct the action. The universal and the individual are meeting in me and touching each other, and this interplay is somehow erotic. I feel the beauty of the union and of the separation, as if I were displaying to a creator the infinitude of its creation. Each of us—dog, lemon, painter, is a fresh opportunity, an as-yet-unknown face of the Self.

How do things change or grow? Through time and by nonresistance. If I try to rid myself of limits such as ego, these obstacles grow denser. Furthermore, in my attempts to enter the inner sanctum, I can't fake it. My real self, like the citadel in the song, is

so high you can't get over it
so low you can't get under it

so wide you can't get around it
you must come in at the door.

Entering that door means bringing along with me everything that IS me. What is beautiful and what is ugly have to share the same bed. I am I; not a celestial substance sullied by contact with the mundane. I AM THE MUNDANE! I have to bring the mundane with me through the door. I have to bring this ego. I can't disclaim it; it will keep showing up. All I can do is to keep moving in the instinctive direction that is calling me. For some reason, this hallucination we call ego is as necessary to existence as that flower, that dog, that dragonfly. Surely all is perfection in the greatest of schemes, but this we cannot know fully while we live. For now, only acceptance of every part of the self gives the mind and heart room to grow. As soon as I come into conflict with myself, the field is narrowed and the power of creative action is hobbled.

Most of our inner conflicts revolve around self-judgement, but art can take us beyond that context without the need of a moral stand. Art is a naked phenomenon in itself. The act of drawing or painting as I have described it is a free inquiry into the next moment, full of discovery and at home with the unknown. The painter stands at her easel with all she is: intellect, ego, heart and soul, and in this totality, acts upon the moment fully, as art. This is the total movement of the mind in time.

Art, like music, takes place IN TIME. The artist brings to painting feelings, thoughts and impulses in a progression of actions and reactions appearing as strokes and marks, each bringing on the next, illusions unfolding in their turn. A painter

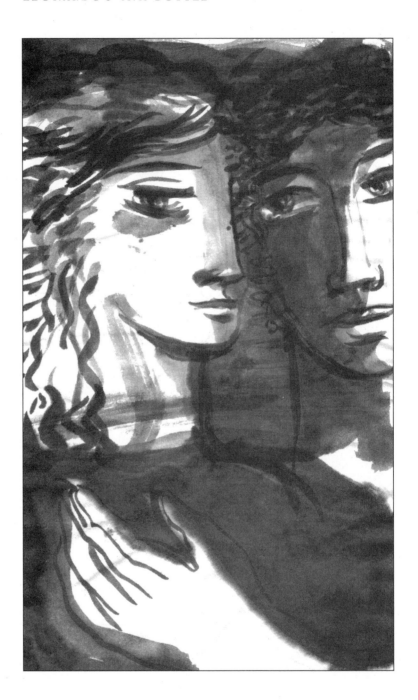

is engaged in performing an art, though he will later be seen as having produced a thing.

Absorbed in art, the sensation is so complete that action becomes a vehicle for our entire being. The artist's heart may plummet and soar to great extremes when working; that is part of the attraction—to be carried along into the unseen by an irresistible force beyond our understanding. Captured by the creative, we flow without restriction. We let go of judgement and enter the realm of total creative expression, fresh and innocent of the past.

Pathways
TAKING ACTION

- Never compare. You are a unique being and you were born to display a specific creative spectrum. Your only responsibility is to nurture this singular expression. We can learn a great deal from the accomplishments and insights of others. Our purpose in meeting with the work of fellow artists is to respond to their inspirations and to incorporate what they have to teach us. This we can only do when we let down the negative resistance of competition and comparison, and allow their works to speak to us in the language of their own personal genius, receiving their offerings with love and gratitude.

- What insights—artistic, intellectual, emotional and spiritual—have you received through the work of others?

- How have these insights entered and altered your own work?

- When working, resist the temptation to become distracted. Whenever possible, let your work guide your schedule and not the other way around.

- Remove clocks from the studio. Absorbed in total inner movement, you may be startled by the swift passage of time. Working, there is only daylight and then night falls. Recall the times you have worked for ten, twelve, eighteen hours at a time. What was the work that absorbed you to that degree of intensity?

- Don't worry if your mind seems to wander as you work. That is just wandering mind. Keep working and the thoughts pass into other thoughts. Sometimes great and illuminating thoughts arise from working. It's all the same thing.

- Remember a time when you were obsessed with an activity. It could have arrived as an interest in a sport or a game, learning to skate or ride a bicycle, or, in your earliest days, learning to walk. It is always so moving to watch a toddler stagger along, fall down, cry for a moment, then get right up and have at it again. The child has a passion to master the new skill and works tirelessly, even wearing out those around it. Bruised, cut, the child does not give up. It is this degree of drive, this passion that takes us into new levels. Without it, all is merely a half-hearted pretense. With this passion, which is full of love, the desire cannot be denied. In this intensity, the total self is united, pressing forward, persisting, and that is all there is to discipline. If an art form is your passion, pursue it! If it is just a wish for a passion, let it go.

Nature:
THE LANDSCAPE OF LANDSCAPE

The whole of Nature is but a symbol, that is, its true significance becomes apparent only when it is seen as a pointer which can make us aware of supernatural or metaphysical truths.
—J. E. Cirlot

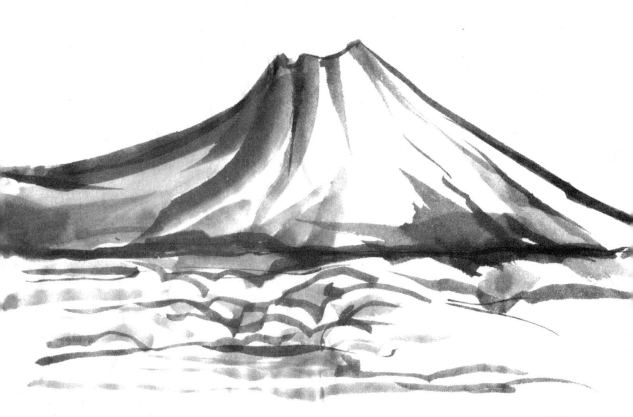

LEONARDO'S INK BOTTLE

Where am I? Arriving into consciousness, I look around me, into the earth and sky, space full of objects like fantastic dioramas of my mind, only infinitely more original and inventive, mirroring all that I can sense, think, feel and know. Landscape, the ubiquitous subject. From the glorious tomb paintings of ancient Egypt and Etruria, to the Renaissance world of visions, trials and transformations, the landscape offers the poetic metaphor par excellence for states of being, expressed in the subtle inks of China and Japan, the Impressionist love of light, the milky moonbeams of Palmer and Blakelock.

With how sad steps, O moon, thou climb'st the skies.
How silently, and with how wan a face.
—Sir Philip Sydney

To know landscape as metaphor is to see it as a revelation of the environment of the mind. The projection of our inner landscape outwardly in physical space arouses corresponding sensations, thoughts and feelings in the viewer. Looking at various landscapes, one can see every emotion from bliss to despair, reminding us that whatever its content, the work of art reveals as much about its creator as it does about its subject. The anguish in El Greco's *View of Toledo* or a turbulent ocean by Ryder, the radiant deliverance of Monet's garden tell not only of places and things, but about the artist's own state of being.

I grew up in a city with a first-rate art museum. The Art Institute of Chicago, among its many treasures, possesses an important collection of Impressionist painting, with its message of intense sunlit color: dazzling reds and oranges and pinks, shadows of purple and blue, strokes like little staccato notes, tiny

blasts of pure pigment. I marveled at their richness and command, their joyousness, their...art! These paintings did not wait for me to approach them; they arrested me from across the room! And though their subjects were the eternal subjects of art—the sky and land, the plants and animals and people, what interested the painters most was the way a subject was revealed by light, so that at times a person's face could be perfectly, logically green. Impressionism was the inspired meeting of art and science; Seurat, for one (whose real genius is in his drawings), gave his attention to optics, and this new way of understanding light was a great and delicious liberation for his art.

On the same floor as the bright rooms of French painters was a collection of American art, and here was a landscape painting in front of which I dawdled away much of my adolescence. I used to hope no one else would enter the room, which was not unlikely in the late 1950s—this was long before museums presented blockbuster exhibitions with long lines of art seekers snaking past official masterpieces, headphones filling their ears with a taped interpretation of what they see, and guards hustling them along! (But I digress.) In that room of American art was a large painting that called to me to come closer. It was a wetlands scene whose atmosphere was misty and diffuse, all umbers and greys with a few subdued pearly highlights. As I looked at the painting I felt something that was alien to my everyday urban life—an exquisite quietness. In the misty dawn of the marsh, a white bird spreads its wings. The nameplate reads: *Home of the Heron* by George Inness. In the hushed palette, in the intimate sensation of uprushing flight at the beginning of the new day, the Inness spoke to my young heart as nothing ever had. Stand-

ing before it confirmed, in an unspectacular and secret way, the hopes and visions of a self with whom I was, as yet, only lightly acquainted.

The images and atmospheres of landscape have the power to convey sensations, memories and the moods of our hearts. We are drawn to certain scenes in nature because they express sensual, logical and imaginative aspects of our personality. Landscapes embody "the sense of cosmic laws which permeate and bind together all of nature." Cirlot, in his illuminating *Dictionary of Symbols,* points out that every landscape has "a disastrous or felicitous tendency," although these tendencies may be mingled and complex. A landscape feature such as a river, for example, brims with life and nourishment, freshness, renewal and a link to the source of life. Yet, a river seen flowing away from the viewer could convey a progress toward oblivion, as in the river Lethe.

The artist is the key. His handling of the subject sets us down on one side of the duality or the other. Consider the mountains, their uplifting beauty, and then think of the mountainous moonlit landscape that looms over the doomed traveler in the film *Nosferatu.*

Landscapes contain elemental properties that stir the mind with their scope and breadth; an artist can create great space on a small two-dimensional surface with subjects that are simple and immediate.

The lake is the first and most expressive feature of a landscape. It is the eye of the earth, where the spectator, looking at it with his own, sounds the depths of his own nature.
—Henry David Thoreau

Water may appear as a lake, a fountain, a river, a stream, a pond, a flood, a waterfall, or, in the work of Bonnard, the generative ocean residing in a bathtub. Spirit signals are the sun, moon and stars, storms and even light itself. Rhythms may be broad and undulating as gentle hills or sharp as steep gorges, rocky cliffs, canyons and tunnels. Fire may be disaster and cataclysm, the fiery furnace of hell or the warmth of a campfire at night. The point of view may place the viewer high or low, close or far away from the scene, enclosed, as in a temple or trapped by a tide against cliffs. A flat landscape may suggest the apocalypse, in which everything has been leveled, or the objectless purity of an unbroken clear horizon. Anthropomorphic features are in abundance as trees and the curiously human forms of rocks and plants. Mental states permeate the atmospheres as clarity or mist, open or clouded skies. Structures of the psyche are visualized as bridges, fences, paths, gates, roads and crossroads. Zones of activity such as the earth plane, the human realm and the heavenly heights, and even tactility of elements are features of landscape in surfaces that are soft or hard, rough or smooth, calm or windswept, fruitful or barren. There is no limit to the range and subtlety of feeling a landscape can express. Some say Leonardo's *Mona Lisa* owes its charm and fascination to the strange unfinished landscape in the background.

In nature's infinite book of secrecy
A little I can read.
—William Shakespeare

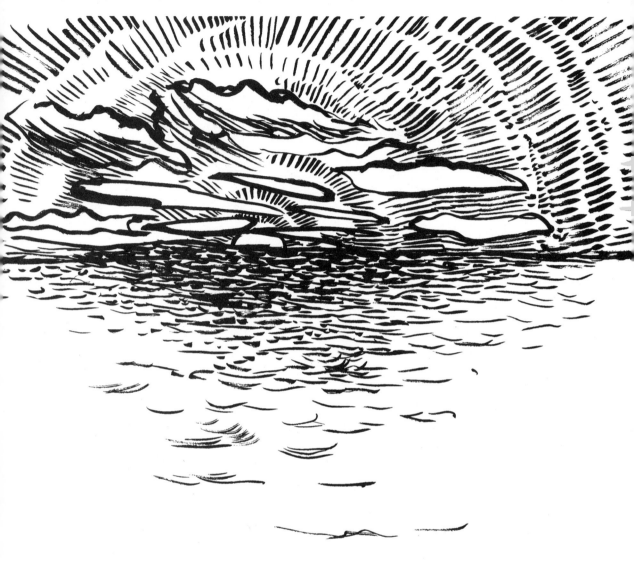

Pathways
NATURAL ORDER

- If you could translate into landscape the mood you feel now, what sort of world would that be?

- Warm, bright and vital? Precipitous and nocturnal?

- What landscape paintings have you been drawn to?

- How do they reflect your personality and world-view?

- Allowing some time for visualization, create an imaginary landscape that expresses the feelings you are experiencing now. Inwardly enter that landscape and walk there, enjoying its atmosphere, its sunlight or starry darkness, its peaceful fields or crashing waves.

- When you go out in nature to observe or to draw, which views and elements attract you?

- How are these qualities in sympathy with your inner nature?

- Observe a range of scale. You may stand before the vast ocean or bend over a frilly fungus growing on a tiny piece of rotted wood, a few wildflowers or insects. Notice the different feelings and thoughts that are engendered by subjects of varying scale. Know your own attractions but also, to uncover more of your inner self, give attention to those views that seem at first alien to your esthetic.

- Whenever possible, take a day trip to a new place. Perhaps different trees, flowers, plants or waterways will stir a feeling, ever so subtle, that can enter your mind and work with a fresh view, a new perfume.

- Find a rock that looks like a miniature mountain. Bring it home and put it out where you can contemplate it. Imagine it as very grand in scale. Draw it that way.

- Look at the landscape of night, the blackness of earth as it meets the luminous dark sky, the stars, the moon and the racing clouds that pass over and around it. Position yourself comfortably to watch the sky, day or night, for an hour.

- Some time when you awaken before dawn, walk through your neighborhood as the sky begins to lift, observing the colors and the atmosphere of that hour.

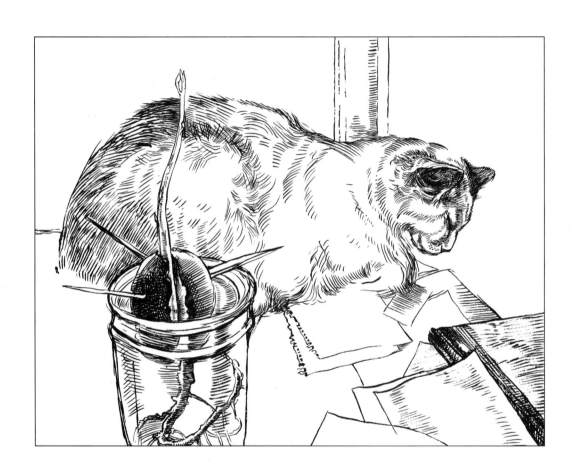

Discipline:
BALANCING PRACTICE AND SPONTANEITY

There is no method...you don't have to impose discipline. And that is the beauty...if you only realize it. If you can see, you have nothing else to do, because in that seeing, there is all discipline, all virtue, which is attention. And in that seeing there is all beauty, and with beauty there is love. Then when there is love you have nothing more to do. Then where you are you have heaven; then all seeking comes to an end.
—J. Krishnamurti

When we see a great painting or sculpture, hear beautiful music or read a transcendent poem or passage of prose, we know that its creator did not happen upon the exquisite expression through aimless play, but brought it forth by the cultivated channels of practice which such works bespeak. We reflect on all the effort, repetition and discipline required to learn composition and technique, whether of forms, words or notes. It is no accident when the inspired moment alights upon a perfectly tuned, prepared instrument.

How does the artist achieve the discipline required to tune the instrument of art? It is not through forced practice, but when we are deeply interested and attracted, that our entire being

becomes yoked to the object of our attention. Without any plan we find a devotion that appears as self-discipline. As a lover who relentlessly seeks out what he needs, when the need is strong the artist works, and with the action of art comes the immediate liberation of thoughts, feelings and sensations as they arise.

Wanting pleasure, wanting freedom from the conditioned, imperfect and unsatisfying world, we yearn for a primordial state of equilibrium. However, our experience which has led us to this point also colors our concept of transcendence. If I try to look through the veil by using discipline—using the mind to control the mind—I am like the dog chasing its tail. Round and round we go, the pursuer and the pursued. (The dog doesn't get caught up in the game—he could hurt himself!)

We have to go beyond the habitual mechanisms of the mind. Just as the body is confined by the limitations of its nature and, for example, cannot fly, so the mind is not able to rise above itself and the boundaries of its experience and memory. The mind's only freedom lies in self-awareness. Who am I? That is the central question we are always asking and answering in everything we create. Art is an arena where I meet myself. It is a window I open in the wall of my ignorance through which what is near and what is far may be seen. It offers a glimpse of the changeless self that wanders through the "floating world," the self whose sensuality, emotion and intelligence draws us into subtler and subtler states of attention and experience.

Following faithfully our desire for understanding, we can obtain artistic independence and a heightened sense of life which stands apart and amazed at the complacent numbness with which we humans generally conduct our lives. Artists are

visionaries whose works display the riches of a specialized sense of perception. Perhaps, like the treasures of the deepest seas, such visions lose their vivid colors when we attempt to wrest them from their natural element. Our efforts are never perfect; they are only a series of repeated approximations. Yet from these repetitions, skills are developed which take the artist higher, energy gathering until suddenly we break through into a completely new context, where we finally grasp the meaning of the one before. This devotion requires trust, because often we will not know where our work is leading us; we only know that we are doing what we must, inquiring as we must. An artist is blessed with an inner guide, but we have to listen to its voice; it must be our final authority.

Self-acceptance is the only way to nurture this strength of the heart. When we know ourselves as infinite beings, our natural wisdom will prevail over the pressures we face. Trusting this inner vision we are free.

To fulfill our vocation in art, we have to develop the skills that are the language of our chosen art form. If I am a visual artist, drawing is my indispensable apprenticeship. I draw from life, from the figure, from the objects on the table in front of me. I humble myself to the laws of objective representation:

Looking outward for the form, I find it.
Looking inward for the way—I find it.

It is never a question of what to draw or paint; all is within us and around us, waiting to be unlocked from the prison of appearances. Whether it is some cosmic vision or the simple life of a moment, if the artist has not grasped it, what can the

viewer take hold of? The greater the mastery, the more subtle the music. Self-discipline is only doing what is necessary, and that is:

Sometimes this, sometimes that.

Pathways
PRACTICING SPONTANEITY

- In art, the spontaneous shows itself as fascination with an idea or object. Our first attraction causes us to look with sustained interest, either inwardly or externally. The more interested we are, the longer we maintain our observation, and inevitably, a response follows as drawing, painting, creating words or sounds, and this action maintained through time is the discipline. The action is purely motivated only so long as the interest continues, which is why there are so many lovely unfinished works in the arts, for there are times when to persevere would destroy the inspiration.

- Can you identify this process in your own work, observing how a work began and was finished in the spirit of freshness, faithful to the original impulse?

- To keep a work in balance during its development, stay mindful of the source, the idea or feeling that inspired the first marks. If the work veers into another direction, see if it can be brought back into the first framework. If not, one can only ride out the new direction and hope for the best. Sometimes it is possible to keep some of the first strokes in the picture unaltered until the end. This can help to preserve the initial impetus. Even though it is a tenet of expressionism to act upon the instant, there is also validity to the way of following a conscious perception to completion. Become familiar with both methods.

- The perfect example of the balance of discipline and spontaneity is to be found in the ink paintings of China and Japan. Familiarize yourself with the underlying concepts and materials and do some work in this difficult medium. When mastered it is the essence of inspired immediacy.

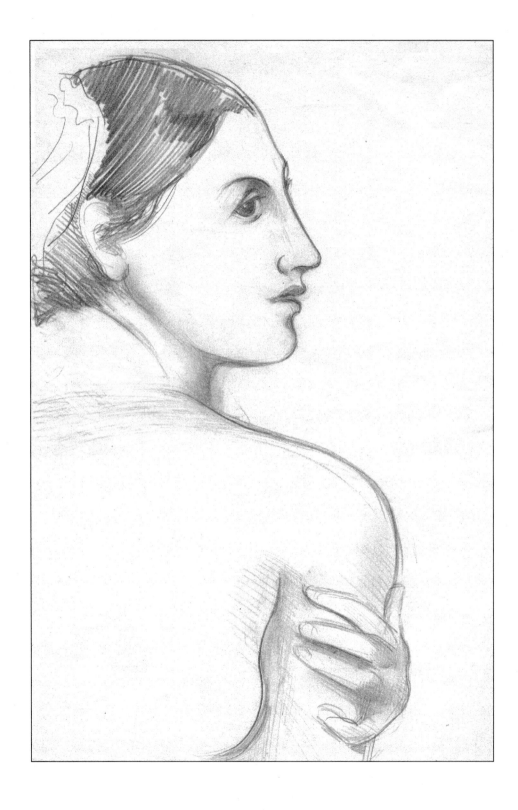

Education:
IN THE FOOTSTEPS OF THE MASTERS

The finest works of art are precious, among other reasons, because
they make it possible for us to know, if only imperfectly and for a little
while, what it actually feels like to think subtly and feel nobly.
—Aldous Huxley

Why do we follow in the steps of others who came before us? How is it that someone who lived far away long ago can be our most intimate teacher? We feel both recognition and astonishment when we see our own most exalted dreams and imaginings realized and perfected in some great work!

When I was seventeen I saw a print of Caravaggio's *St. Paul on the Road to Damascus.* In this painting Paul has just fallen from his horse, his arms open to the ecstatic vision only he, in his sudden blindness, can see. His piebald horse and his groom stand over him in the raking light of a single lantern in darkest night. Awareness of this painting caused a shift in my relation to art. On the one hand, I was overwhelmed with admiration, but also I despaired of ever being able to rise to that supreme level of expression, without which, it seemed to me, there was no point in pursuing art. That was how I experienced it then. I felt as if I'd been born in the wrong age.

In San Francisco in the late sixties, after a concert by the Incredible String Band, as the crowd was leaving the theatre, I saw two policemen attempting to take a woman to their patrol car. She had fallen to the ground, and, like St. Paul in Caravaggio's painting, her arms were flung outward, her body arched as she tossed her long red hair from side to side, crying out, "Yes! Yes!" To the police, no doubt, she was just another freak on acid, but I was transfixed seeing this woman in ecstasy, reborn to a world of glory while everything around her went on unchanged. I walked on but I never forgot her. Perhaps it was a similar sight that caused Breughel to paint his *Icarus*; the bizarre juxtaposition of realities, where the incredible moment takes place quite unnoticed.

> *Art begins with imitation.*
> —Eugene Delacroix

Identifying our strongest influences, we see that we are most receptive to works which resonate with who we already are. I love most those artists whose sensual inclinations I find delightful, whose technique, whether rich or spare, is masterful, and whose thoughts, feelings and insights touch and awaken me. After the age of fourteen I found I could draw instinctively with conviction, but painting presented the classic dilemma wherein each artist must become the first artist. I had to discover my own way of going about this business of moving liquid colors over a surface. Where drawing is perception itself caught in its movement, painting has far more likelihood of failure. I want every painting to be miraculous. And since a painting is an extended work, it has more opportunities to die.

What I have learned about what is possible has come not only from my own attempts. How would I have known what could be expressed had I never been shattered by the art of another? An obscure painting in a museum, a minor photograph in an art book or catalog, what someone did that I had vaguely thought about and that they had turned inside out has both humbled and uplifted me. I have experienced this recognition with art of every age and style: Paleolithic ivory and bone carvings of horses and antelope; cave paintings with their suppleness of line and smoky shading; the massive, mythic sculpture of Mesopotamia; the elegance and mystery of Egyptian art where human and animal forms merge into deities. I feel especially drawn to the broken-nosed black granite head of Amenophis III at the Metropolitan Museum in New York. Cretan painting, so full of light and pleasure; Greece, the fourth and fifth centuries B.C., the eyes of the Charioteer of Delphi, Praxiteles and Scopas, all known to me through photography and books. Of the Greek art I have seen, I am amazed by the life-size clay sculptures in the Getty Museum in Malibu, California—a seated Orpheus flanked by two sirens, one who sings and one who listens. What anomalous mystic could have created this work? It is like nothing I have ever seen and does not seem Greek, but as if it came from some Romantic age. The heads and torsos quiver with life. The sensitive modeling of faces and flesh is the work of a sublime master, curiously contradicted by the stiffness of the bird legs that support the sirens, doubtless the work of another hand. Pre-Columbian sculpture awes me with its ferocity and sensuality. The Renaissance in Europe seized my imagination utterly

and I copied the drawings of Da Vinci, Michelangelo, Andrea Del Sarto and others. I then copied paintings of Rembrandt, Ingres, Toulouse-Lautrec, blue-period Picasso; I drew the sculptures of Maillol and studied the crayon technique of Millet. Every time I copied a work that I loved I advanced in my ability, because by copying, I came to understand and to incorporate how a difficult thing is done. I grew more from this practice than from anything else in my formal art education. I don't think copying masterworks is a highly regarded educational tool now, and, alas, there are ever fewer proponents of these skills, which are beginning to be thought of as "lost" or in any case, obsolete. I deeply admire the work of Fragonard and Boucher for their incredible displays of virtuosity in flesh and fabric. A Corot in the Art Institute remains with me; and Inness; the nocturnes of Blakelock and Albert Ryder. So many known masterpieces, and then there are the infinite works that float through the world unsigned, unacknowledged; all belong to us. So although we may never experience direct teaching from a master artist in this lifetime, we have the works of our teachers before us in museums, prints and books. These works are alive with the creative energy that spun them, and we learn by contemplating them and by copying them, taking time to see as we take time to hear the music we love.

The Sufis tell us of the realm of the djinns, someplace above the earth but perhaps a bit below heaven, where artists, poets and musicians play out their inspirations. Souls passing through on their way to the earth plane, they say, are sometimes endowed with gifts from the sympathetic masters of this realm; and so there are affinities amongst artists of all times.

Pathways
FOLLOWING GREATNESS

- Select some drawings by masters and copy them. Use prints or make the pilgrimage to the museum. Make your copy the same size and the same medium as the original. Find a paper similar in tone and texture.

- List your favorite artists and influences across time and culture. Try to discover the common elements of all the works that form their appeal for you. Become conscious of these qualities and recognize their appearance in your own work.

- So many great artists have left us their thoughts in words—Da Vinci, Cellini, Delacroix, Rodin, O'Keeffe, the letters of Van Gogh, Redon, books by artists on all subjects and media, philosophical treatises by Klee and Kandinsky. Familiarize yourself with these works and contrast and compare these artists' thoughts and sensibilities with your own.

- Pin up a favorite print and gaze at it for an hour.

CHAPTER 25

Consciousness:
HORSE AND RIDER

A horse! A horse! my kingdom for a horse!
—Richard III

The conscious, subconscious and unconscious are not three different minds; they are modalities of one consciousness, one awareness—it's just that we are not always aware of our awareness.

We know the conscious mind as thought, speech, waking perception, beliefs and goals—the analytical mind, the social mind.

We know the subconscious as the repository of suppressed, unacceptable or hidden thoughts, desires and motives. These are visible beneath our conscious expression in the telling gestures we make and in our speech and manner which betray truths we wish to remain unknown to ourselves and others.

The unconscious is the oceanic current of instinct that underlies all our actions and perceptions, both waking and sleeping. Here are the hidden treasures, as well as the gods and demons we share with all of humankind. In the unconscious is written the entire history of human and animal life; the collective memory of our species and the primal knowledge of our bodies and souls. This is the boundless and liberating field of consciousness; immeasurably vast, deep and wise, containing

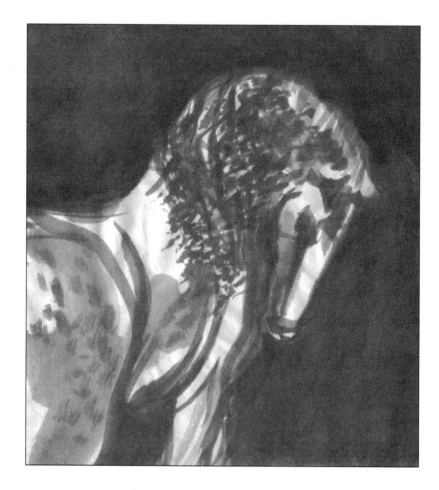

all illusions and all realities, as emanations of MIND. All forms arise spontaneously from the play of this mind.

That is why we turn within for the ultimate reality. Where is this "within" located? Everywhere and nowhere. How do we perceive the unconscious? Through the imagery of dreams, visions and art we touch the infinite, supernal world.

We are drawn magnetically to the unconscious. How can we unite with its power and abide there? Imagine this power as a magnificent horse, an energy unbound by thought or plan. This

is the animal we must ride through the dangerous landscape of our life. The spirit of this horse can never be broken—its indomitability assures us we will still be human beings when computer chips and cloning have regulated us into unheard of extremes of conformity. The unconscious is unchanging, absolute and eternal.

If we do not fear the unconscious we can mount and ride it, but if we should fail to befriend it, its force can devastate us, because it will not be denied its life. Under pressure from the outer world our instinctive nature may be suppressed but it cannot be extinguished. The frustration of natural instinct causes us endless suffering. In our struggle to survive, the unconscious has become like the dark side of the moon, always orbiting unseen. But if we can open and embrace the unconscious, we can learn to balance ourselves in the primal mind as adroitly as an acrobat on the back of a prancing circus horse.

How do we mount and harness the instinctive? In the taming of horses there are methods of gentling the animal into accepting the halter. The rider offers affection through voice and touch, and when the time is right, slips onto the back of his beast unresisted. If we don't gentle our horse, we will have to take a bone-crunching ride, and the gleam of the unconscious will appear to us as darkness and shadow.

Artists have loved the image of the horse since prehistoric times. The sooty paintings of Aurignacian cave painters, the bolting steeds of Fuseli and Stubbs, the glossy muscular giants of Rosa Bonheur, the ghostly mount of Rembrandt's *Polish Rider*, are all images of the beauty of animal instinct. Sometimes our horse, our instinct, is all we have to support us.

Can you recall an experience of wild unexpected exhilaration? When I was a child of four my mother took me to a pony ride. A man lifted me into the saddle and started me on the course. Suddenly my pony bolted and started galloping. My mother screamed and the man ran after us but my pony ran faster and faster. I clung to the pommel of the saddle, flying through the air with each stride, feeling the rushing wind and the wonderful clatter of hooves. Nearing the endpoint of the track, my pony flew right past it. My mother was still yelling and the groom was still chasing us and I was just laughing and having the time of my life escaping them; no fear, just great excitement, sheer pleasure, absolute bliss. This joy bursting from the heart of nature itself elevated my spirit so high that day that fifty years later it remains a defining moment of my life.

A child can ride without awkwardness, without losing her balance, because her body and mind are innocent, young and pliable. She feels no fear; she has not yet built up the barriers of thought that imprison adults, so she has a natural seat in the unconscious, a natural bond with that mount. We can follow that child's example of trust, facing our fears and our passions.

The good rider is one with the horse. The unconscious is never apart from us; we are not only the rider, we are the horse! As artists, we accept what arrives and claims us, knowing our own dreams and images are identical with ourselves; light and dark together, recognizing ourselves in everything and every being we see; loving ourselves in everything we create; riding our pony and allowing ourselves to be completely carried away. The power within us is greater and deeper and more enduring than we know. We have to tie ourselves into the saddle and ride,

if we want to be free. Without the passion, the excitement, we can't touch the depths. We have to surrender as easily as a child and with the trust of a child, to see what may happen, to be unafraid. To say in our heart, in our speech and in our work, what we must say. If we ever think we have nothing to say, it is only that we are afraid to say what we feel. The fear of expressing what we feel shrouds the feeling, numbs it.

It is to resuscitate the mind and restore our innocence of heart that we delve, that we seek the way out of our confinement, and in this search art is a great tool. Arriving before the inner universe in fearless inquiry, we are ready to ride, to release the force of instinct and to manifest it in its myriad shapes.

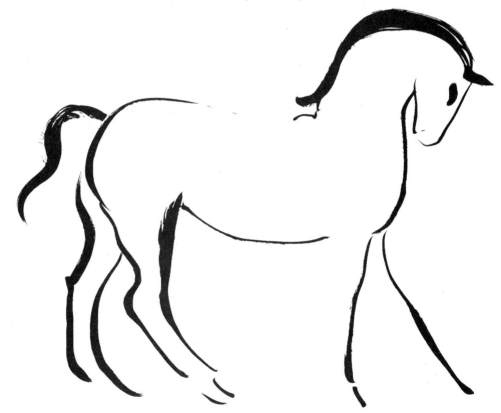

Pathways
REGAINING CONSCIOUSNESS

Connecting with the unconscious we may have to pass the three-headed dog that snarls at the gate—that is, the face of our fears. We can meet and overcome these fears if we visualize our monsters and find a way to depict them. See if you can conjure up an image that frightens you. Draw it, paint it, holding the fearfulness and ferocity in your mind. You will find that as you complete the picture, the image is no longer fearful, it has become only an image, like any wrathful deity, a creation of your own mind. This is opening the gate to the dark side, which, exposed to the light of conscious awareness, loses its power to injure us. Look at depictions of demonic forces in the art of various cultures and see if any of these feel familiar. If any do, copy them, and give them names from your own personal pantheon. Catalog your fears and give them faces: fear of death, disease, defeat, pain, imprisonment, abandonment, fire, flood, and loss of all types can be overcome by studying them, dissecting the fear and exposing its origin. The expression, with complete candor, dissolves the fear.

- Can you visualize an image that represents a link between the human and cosmic realms?

- Draw the first things that enter your mind, as natural or symbolic forms.

- Can you visualize an image of complete harmony?

- What forms arise as place, atmosphere, plant or animal life?

- What abstract forms, such as circles, stars, meanders, etc. hold the scheme together?

- What archetypes are rooted in your psyche?

- What forces do you identify with? Do you have a totem animal?

- Draw yourself and this protector animal together.

- What activities or phenomena appear in your work, visions and dreams that transcend ordinary reality, such as flying, breathing underwater, moving through the underworld, being in two or more places at once, being invisible, etc. Make representations of these inner movements, allowing your imagination to develop these pictures fully and without restraint.

Part Three:

ART & LIBERTY

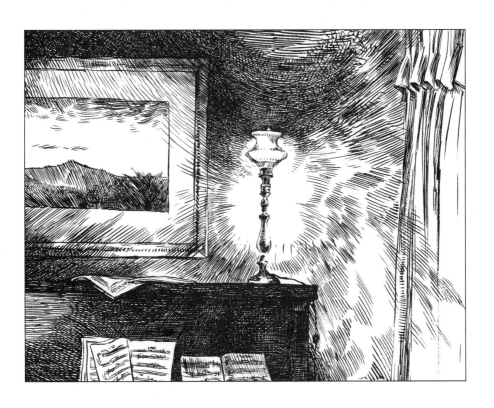

Time:
WATCHING
THE RIVER FLOW

Nobody sees a flower, really—it is so small—we haven't time,
and to see takes time, like to have a friend takes time.
—Georgia O'Keefe

My friend took me out to the hills and we walked for miles, sharing the wild iris, the pair of crows on a rock, our thoughts about art, nature and the spirit. Along the Marin coast above Inverness in Northern California it was late spring, and the local herd of tule elk were in rut. Males with huge racks lay in sight of one another on the crest of a hill, serenely gazing as the sun began to drop to the horizon. Late afternoon and it was the loveliest of days, the best of company.

Had I been alone, I think I might perhaps have walked only half as far, and with daylight to spend, I'd have left the path and gone into the field, found a comfortable spot to just sit and watch the folding day. There were two varieties of iris; one a soft grey-blue, the other creamy white. There were bees, moths, butterflies, snakes, rabbits, and lizards in that place, and many other animals, which I could only see if I could be still enough

for the landscape to close over me as if I weren't there. Then I could know the life around me as it really was. I could lie on the earth and float with the clouds for a long, long time, as I had when I was a very young girl. In those days we used to go to the sand dunes of Indiana in the summer. I would spend every day on Lake Michigan lying in the distended inner tube of a truck tire. Wavelets would strike the tube with tiny slaps and pings that echoed within my little ear pressed against the hot rubber exactly for the purpose of hearing sound amplified and hollowed out in that particular way. Then with my head back, I would look straight up into the sky. The brightness hurt my eyes at first and stinging tears would well up, but as my eyes adjusted, the whiteness of sunlit clouds would start to throb and open up until my eyes were grown as big as the sky itself. Then, it seemed, I was up in the sky, floating not on water but on air, on masses of clouds like feathery continents. Upon these snowy fields whose depth is up, immense beings would form, interact and dissolve. Momentous mergings and clashings occurred as one shape gave way to another and skyhorses traded places with kings and queens.

To be receiving, quietly receiving and using the senses to observe and absorb without hurry, without judgment, without any goal at all is so easy, and so liberating. To witness the colors of sky and clouds, the changing light on ocean and earth, the blue wings of the dragonfly who, because I have not moved, now rests on a stalk only inches from my eyes like a fantastic brooch of opal and glass, with huge obsidian eyes and a segmented body like beads of iridescent turquoise.

People pull into turnouts, jump out of the car for a quick look and drive away. They have seen it. They've brought the camera, caught the cliffs, the surf, the seals. But the life of a place has its time element. To know that place, you have to stay there and let some time pass. And time is so elastic, we can expand time by stopping our own movement. Watch the sky or the ocean, a herd of animals for an hour or a day—countless events are occurring, relationships interweaving, destinies are being fulfilled each moment.

Seeing, observing, listening, these are the greatest acts.
—J. Krishnamurti

The greatest acts are not recognized in our society, with its emphasis on doing, achieving, accomplishing, and yet they are the highest attainments, from which creative expression flows. Without them, there can be no creation; they are the key to releasing creative energy. If we take nothing in, what will we have to give out?

So, practice observing, listening without a specific goal, and see where it takes you.

Pathways
CLOSE ENCOUNTERS

- Aspiring to the great acts of observing and listening, go where you can simply sit out in nature and watch the sky on a beautiful warm day, with a blue sky upon which scattered clouds are massing. Looking up into the clouds, be aware of the various strata that the different types of clouds occupy, how they pass over and under each other. If you keep gazing you may suddenly get a sense of the depth, the immensity of space in a new and different way. Take time, take time.

- For one day, in every encounter, attempt to be passively receptive. When you are at the store, or having your car repaired or some such errand, step back inwardly, creating a space for the other person to come forward and to express themselves. Stay calm and resist the urge to assert or explain yourself. See what happens to the spirit of the communication. Observe how often you say yes or no.

- Observe animals and insects and birds, not only to see how they look, but to learn what they do. Look at the ants, aren't they just like people?

- Watching someone from behind, how long until they turn to find out who is looking?

- How long will your dog meet your gaze? Your friend?

- Take note of the music of a particular place. Set a tape recorder out in your garden for half an hour. Replaying it, is it not as evocative as a photograph? You can also do this experiment with a video recorder at sunrise or sunset. This can be a beautiful tape to see, in which nothing, and everything, is happening.

- For a whole day, notice your breathing in everything you do. You will forget, but you can pick it up again.

- Watch the moon caught in the branches of a tree, and remain watching until it is again afloat in the sky.

Meaning:
WHAT DOES IT MEAN?

The mind is enlarged and elevated by mere purposes,
though they end as they begin by airy contemplation.
—Samuel Johnson

Life itself is the meaning, though it seems to elude us. I awake each morning full of dread, a dying organism among a clamor of other briefly lit lives, busy as ants and as insignificant; a mote, no, not even a mote, in the endless universe. This is the mind of 5 AM. The birds beginning to sing do not ask or complain, the sky lightening to gold, the waving arms of the redwood, the ripening fruit on the trees all tell me there is order, beauty and richness, even when my mind cannot connect with it.

Is it possible to bypass thought, to waken each day to this world as simply as a bird? To live and to sing, and then to drop from the tree of our life without regret. Trust, trust in the beauty, the order, the sweetness we can see. The natural world is the countenance of being. Yes, there is dissonance. We perceive the noise, or we perceive the phenomenon of its arising and subsiding.

When my life is over, shall I be annihilated? I, the center? Somehow this sense of our life in a body is like trying to pour the ocean into a bottle.

Wednesday's art review tells me that a prominent New York gallery is moving its location from Soho to uptown. The very gallery that had begun the exodus of art to downtown is moving back. Is this a meaningful trend, the writer asks? The first show in the new location features thinly sliced cross-sections of a cow mounted on the wall. A halved pig is another of the exhibits. It is cleverly rigged with a motor that causes it continually to split open and rejoin itself. The show is a sellout.

I really must cancel the newspaper delivery! To be with myself without the invasion of the sad, sick thing media calls our culture, the culture of greed which processes us like Spam. The movie *Soylent Green*, which was produced in the 1970s, presents a dehumanized future that has already come to pass: masses of homeless and the depraved who prey upon them, the overcrowding and decay of cities, institutionalized suicide; and finally, have we far to go before someone calculates the waste of burying and burning the bodies of the dead, when there is all that available protein?

The order that we see in the natural world is the proof of the vastness, grandeur and unity of Life. Turning to this, I can regain acceptance, optimism and remain quietly receptive, a vessel for the energy which flows through and operates everything. When painting, we become single-minded. To be quiet amid distractions, to unpollute the mind restores us to a neutral state wherein we are released from the tyranny of fear and depression. We can go back to the original teachers; the sky and trees,

the plants and rocks and animals. Art is, for me, not some clever attitude or the means to shock. Art is humility, devotion, practice, achievement, completion.

While painting we are creative and receptive at once. As in meditation not doing is doing; not acting is acting. By witnessing, receiving, transmitting, we are immersed in the current of life.

I am one little fish, and the fish cannot possess the ocean; it is too small. But by not resisting its fate it receives everything it needs, though it will never possess, that is, understand it.

I am a visual artist, and, I confess, I am in love with forms. My mind's efforts, my art, all spring from the absolute and complete belief in, devotion to, and love of forms and all that is within and behind the forms, even while I know that what I love is constantly passing away. Sometimes we feel a distaste for life and its illusions. In art we can touch and celebrate all that is here with us now. Through art, we transcend the conflict and the sorrow of it; not only through action, but by letting be. Just allowing everything to be as it is, needing nothing in particular to happen, is happiness. And in this spirit of complete acceptance time is overturned; now the world itself is a book that tells me the immense Intelligence exists and that I can touch it. Can it be this mind is seeking to touch me also, as it touched me through the stars so long ago?

When we are happy we have found the meaning and when we are blunted, lonely and depressed, the same world which turns at the same speed around the same sun, is all ashes. What is Real goes beyond any notion of meaning we can have.

Having no purpose, all is complete; no purpose but to witness. In art we find the purposeless purpose by combining dis-

cipline and abandonment. It's a trick, like whistling two notes at once, but it can be done. We can't find meaning by searching or seeking. When we are fully, innocently alive in the moment, our seeking has come to an end. Our art has become our nature.

Look not meanly on the world, for that the world is passing away... —Jalal al-Din Rumi

Pathways

MEANINGFUL PURPOSELESSNESS

- Pretend that you have already died and walk through a world without you. See everything without a center.

- You are gone. Now what do you see? Try it.

- Who is looking?

- As you move through the home of the one who has died, seeing their possessions, their books and objects and works and letters, what do you feel about that person?

- Let fall a drop of ink into a glass of water and watch it. What is the meaning?

Indifference:
NO TIME LIKE THE PRESENT

Many days and nights I was guardian of the
pearl of my soul; now in the current of the ocean
of pearls I am indifferent to my own pearl.
—Jalal al-Din Rumi

It is impossible to live and not do harm. Equally it is not possible to live without being harmed. So the wise don't say never to harm another being, they say "Do as little harm as possible." Today in pursuit of order I sweep the floor and murder a mayfly. Fragile wings flutter for a moment, but the broom has pulled off a leg and mangled the intricate system.

The slightest action in our life affects every other life. Why do we want everything to live? And if this feeling is an echo of Eros and the creative, is it a feeling that is disappointed in living through the harsh lessons of life? As we grow up, we learn about the world; both the natural world and the even more brutal world of human society, so full of fear and destruction. We come to realize that in the round of worldly existence, beings live by dominating and destroying other beings. Our concept of success requires that someone fail. Throughout our lives we are trained to fight the very ones with whom we could share love and comfort on this bewildering journey. Why should we travel alone?

Seeing that everything we know is dissolving, that all life is a cycle of endlessly alternating patterns of growth and decay, one senses that all of this is a covering for something invisible which encompasses the whole display. Just as the voices of a thousand people murmuring before a performance blend into a single sound, which has a voice and timbre of its own, we are the multitudinous parts of a greater being. We are like the shards of a broken mirror, all fragments containing the same, whole, image.

Thinking of this, everything becomes irrelevant. It is irrelevant how any person may see us or our work, which we have created for reasons beyond our own understanding. The product of our work becomes irrelevant. We are only following the path that fate has assigned to us. We walk a path of seeing things as they are, and this path has no destination. Realizing the transitory nature of every thing, we love life all the more this instant. Entranced by the sight of a blossom, a butterfly, we leave ourselves, that is, we leave the concern about ourselves and enter a state of attention that is unobstructed; and the generous universe has supplied us with things to see that point the way. Through our art we are responding, reaching back to the limitless sky.

So eventually we learn a kind of indifference about what may happen, and what we shall wind up with. We are going to die anyway. Only one thing is within our power and that is to follow our calling, to follow our instinct and intuition, and each of us has to answer to our own destiny.

It is not easy to be an artist in the world. Most of us will never enjoy a prosperous life; we must not long for the future. All we have is this moment. And nothing depends on the outcome.

Pathways
LOSING ATTACHMENT

- If it is true that the past has disappeared and the future is nonexistent, this moment is all time. Think of the fact that the only time is NOW. Think of the fact that both past and future are merely objects of thought, thin and unpalpable, unlike NOW.

- The room you are in now is not the same room you were in a moment ago. How is it changed? The room of now is actual. The room of a moment ago is only a thought. It is a subtle distinction that alters our concept of reality. If reality is only NOW, then nothing is as we thought it was. It is not so easy to taste the essence of NOW, yet all time is contained in this phenomenon. If we learn to know the NOW, we shall become indifferent to every concept and every object and every idea. There is only one thing we are not indifferent to and that is the indescribable NOW, which pulsates with the secret essence of life.

- When you are working, give up any attachment to the result of your work. Work only to see clearly and to feel purely from one moment to the next. Allow what takes shape from your expression to become itself without interference.

- Abandon any thoughts of building a career upon the work of your heart and spirit. Work for your own fulfillment.

- Be steadfast in the face of circumstance, good or ill. Whatever comes, it will doubtless pass into its opposite. "Fortune and calamity are twin sisters."

Philosophy:
EAST AND WEST

Art is not a pastime but a priesthood.
—Jean Cocteau

Eastern philosophies seem to say that the individual person doesn't really exist, and that what we in the West understand to be our self is an aggregate of karma and experience, a stream of events, memories and perceptions held together by thought moving in a pattern. The repetition of patterns of thought, it is said, gives rise to the sense of a distinct and separate entity, a self, a me.

According to this way of interpreting Eastern thought, all sentient life is mind, one mind, all is one self and the individual self is an illusion, perhaps a delusion. The goal of self-development in this view is recognition of the true self-identity, the root of every thing; self untrammeled by distinctions, unlimited by space or time, permeating and transcending all qualities and states of being, encompassing both being and nonbeing. If all consciousness originates in this infinite nature, it is not possible to approach this infinite nature since I have never existed apart from it or outside of it. All my effort toward self-realization must aim at awareness of my essential indwelling identity. Other than this, there is nothing to achieve and nowhere to go.

And yet, "Eternity is in love with the productions of Time."

What does this mean? Does it not mean that the unlimited self desires—requires—the experience of limitation; fragmentation into monads, individuals, entities and things? As the self lives in indivisible perfection, it also lives in and enjoys separateness and individuation. It is not a question of either/or, but of either/and; otherwise there would be no creation. It is a paradox, for both states exist at once as an alternating current in the mind itself, which is the original medium of time and space. So the individual and the indivisible essence are one and the same.

The individual is the vehicle of life. It is this conjoining of mind and sensual experience, magnificent and expansive or restrained and subtle, that invests all great art. This instinct already exists within you; you cannot acquire it. The delight of every pursuit of humanity and every creation of nature—mountains, oceans and infinite prisms of sand, each animal and plant and being is a mirror and a love object of the self. The infinitude of the monad, the person, is represented in both our multiplicity and our singularity; repeating and repeating the great "I".

Within everything around us, in all the beauty, all the sorrow, the I is searching for the YOU. I and YOU are the cause and the goal of creation, the streaming out of Being into being, and being into Being. Light spreads and YOU ARE THE WAY.

Painting, YOU and I are the one and the many. Merging and separating within and beyond what is seen, the hand of the Creator reveals itself. Other than this, "All is but toys."

Einstein said "I want to know God's thoughts" because he was a man of science; intellect was his doorway to the truth. To the musician the way is sound, to the artist the ultimate is found in the visible sensual phenomenon of form. The artist's mission is

to come to it with all our skill and inspiration; to use our gifts to grasp life and know it as it really is—a projection of thought, an illusion, a work of Art.

The individual is an instrument for Someone to taste its life; Someone permeates all creatures through their experience and thereby closes the circle of consciousness from the luminous unity to the smallest cell. The Sower casts his field with seeds that grow rooted in earth and bound to its laws. He leaves them to struggle and grow, and harvests them in their time.

The Eastern ideal of unity is a view of fulfillment and bliss in nondifferentiation, but the other side of that coin is the light of the unique and individual insight. Transcending logic, East and West interpenetrate and merge in one philosophy.

As once the wingèd energy of delight
carried you over childhood's dark abysses
now beyond your own life build the great
arch of unimagined bridges.

Wonders happen if we can succeed
in passing through the harshest danger;
but only in a bright and purely granted
achievement can we realize the wonder.

To work with things in the indescribable
relationship is not too hard for us;
the pattern grows more intricate and subtle,
and being swept along is not enough.

Take your practiced powers and stretch them out
until they span the chasm between two
contradictions...For the god
wants to know himself in you.
—Rainer Maria Rilke (trans. Stephen Mitchell)

Pathways
PARADOXICAL UNITY

- Allow yourself to feel the I and the You of the painter/painting—the oneness of the hand and the brush, of the artist and the image that looks out at us as both self and other, the double identity and its synthesis into one. Do you see yourself in what you have created?

- Can you look at your work and say "There I am." Not it but I?

- Try saying your name when you look at your work, thinking yourself already gone, your identity persisting as this work.

- See how, lost in your work, you alternately lose yourself and reappear, are annihilated by your own action, and restore yourself, ex nihilo, out of nothing.

- Allow gifts to arrive as unbidden images. Your pencil or brush has a mind of its own. Let it have its way.

- Considering the duality of self and other as artist and subject, interchangeably, is it possible to separate the impulse from the act?

- As you work, can you feel the expression flowing through you without obstruction?

- Where is it coming from?

- Can you conceive of the unconscious as above, rather than underlying the conscious mind?

- What visual imagery does this concept give rise to?

Childhood:
THE REDISCOVERY OF
THE WORLD

Looking for beauty we find beauty. Looking for violence we find violence. Looking for transcendence we find transcendence, yet the way these qualities arrive surprises us. Beauty may be found amidst squalor, violence hidden in good deeds, transcendence wrapped in the mundane. Only our subtle instinct and discernment sees through the concealment. "Seek and ye shall find," the Bible says, and it is often true beyond our wishes. Only a deep inquiry into our own hearts reveals the direction that is right. We are born seeking something, and each of us has all we need to find it, if only we can allow our perception to operate.

When I was a child, my bedroom looked out on an alley of backyards full of birch, maple and catalpa trees. On days when I was kept home from school because of illness, I would lie for a long time in my bed next to the window and watch the trees. There was a drama, a kind of narrative in the gusting play of the wind which sang to the trees and charmed and tormented them, I thought, for their waving arms and torsos seemed to bend and moan to the dominion of the air, and to complain of their rootedness. My mother used to wonder how I could gaze so long at nothing, but she couldn't see that the world outside was charged with feeling in a way of which it was not possible to speak. One day a magic bird landed on one of the far trees. It had a black body, a white belly and, incredibly, a scarlet head as bright as fire. For a long time I watched the bird wind its way up the tree then settle on a branch for a few minutes before flying

away. I had never seen anything more exotic than that flash of vermilion. When I told my mother about the bird, she said I'd seen a red-headed woodpecker. Yet somehow this identification dismayed me. I felt that everything which spoke to me vividly in the world had a name and a history which evoked in others only knowing, a knowing that was saddening, like an enclosure, and it has taken a lifetime to come back to my childhood's window of secret seeing.

The child sees what is, directly, without naming it, innocent of knowledge, category, image. It doesn't say, there is the tree, there is the bird—because interest, not knowledge, coaxes it to look, to come closer to the object, which is always new and mysterious. And so there is no space between the child and what it sees; that is, there is no separation, no naming, only naked seeing.

Preserve the enchantment, keep it a secret.

Pathways
RECOVERING INNOCENCE

- Go back in your remembrance to a time when you knew not what you saw—animal, plant, human, a rainbow or caterpillar, a firefly. Before you knew the name of the thing, didn't you only look in wonder, full of not-knowing, which is so innocent? The thing spoke to your attention, which rested in the state of I-don't-know; in perfect receptivity. In that attention the tiniest thing—an ant—became very large! Each thing observed with this innocent eye is that moment's monarch and instructor.

Later we are shown by others that these wonders are "merely" an ant, a worm, a helpless thing whose light we can trap in a jar, or squash out with a finger. It is "only" a firefly, a thing named, classified, dissected.

This is the fall from grace into the rational world—the mythical creature that flies from tree to tree, a bright flag of life, is a red-headed woodpecker. Naming is possessing, enclosing what we see within thought, and with this possessing, we have lost the wondrous.

Watch a baby look at a dog. It is all wide-eyed attention. The parent says, "See the dog! Dog, dog, dog." Now the child, distracted from seeing, has shifted its attention to naming.

Naming is the event, seeing is the tool. "Dog, doggie," the child says, and now it's about the sharing of the parent and child, the child pleasing the parent and itself by naming, owning and mastering the experience. The next time the child sees a dog, the focus has already changed from innocent attention to the work of capturing an object through thought. Here is the very beginning of the wedge between the observer and the object. The live dog which drew the child's attention has been enclosed, miniaturized as an image in the child's mind, coded as an idea. Thus the entire scope of life shrinks to the size of a word, a TV screen.

It is not wrong—we should find it more wrong if the parent did not stamp the child's mind with ideas. It just is; it's the way we grow, how we are acculturated. It's all the same as if, in another culture, the dog were seen as a spirit or demon and the child were taught that. Any identification is a reduction of our experience, a loss of innocence, a limitation of seeing. Yet it's a necessary process of life. The great thing is to learn to re-experience it the first way, to return to the pre-conceptual act of seeing, the sensation, the immediacy and the unity of it.

- By understanding that we have many accumulated images between us and everything we see, the rigidity of this reflex begins to dissolve. When we can see the tree and continue seeing the tree without the idea of the tree, we have rediscovered the innocent eye.

- The artist's practices lead to this freedom of seeing. We set aside the idea, the naming, the possessing, by using an alternate set of values. Instead of naming the thing, we are looking and finding abstractly. We don't see "tree", we see verticals, diagonals, horizontals, we see green, blue-green, yellow green, ochre, umber, we see upward-rising, outward-fanning, stretching, reaching, swaying, drooping forms.

- Observing the qualities as FORMS, without the idea, we go past the mental image, staying with the forms as unidentified phenomena for as long as possible. Looking without naming, we are coaxing the mind to drop every preconception, and with the simplest of means, a pencil and a piece of paper, we rediscover a freshness of vision that opens us.

- Looking at a tree or a flower by Van Gogh or Durer it is so clear the artist's whole being went out into that object, in a context in which there is no separation. Van Gogh painting a vase of sunflowers sees himself, life and the universe at once.

- Remember yourself as a child. Put up an early photograph of that child and ask it for its memories, its first experiences, feelings and sensations. Can you remember that hairy caterpillar through the eyes of the child lying on the sidewalk, studying the unbelievable?

 Remember your desire to touch everything and how all the animals, birds and insects ran for their lives at your interventions. Didn't you want to touch a bird? Did you try to sneak up on them, only to have them sense, with senses you did not have, the danger? Did you learn you were a dangerous creature when you hurt that beautiful butterfly or saw its color come off on your fingers? Do you remember the shame of it?

- To dissolve preconceptions we can learn to keep our feelings to ourselves. Our efforts to see are nurtured in the hothouse of secrecy. Some things cannot be communicated verbally in ordinary speech and often when we attempt to do so, the deepest feelings lose energy and dissipate. So when we are inspired, or have experienced something deeply and with beauty, we can try keeping it to ourselves so that it can incubate and come to fruition without interference.

CHAPTER 31

Home:
BACK TO THE STARS

SCIENTIFIC EVIDENCE OF LIFE ON MARS

Space scientists said yesterday that they have discovered the first
"compelling" evidence that microscopic life existed on Mars more
than 3 billion years ago, when water was plentiful on the red
planet and giant rivers gouged deep canyons across its surface.
—*San Francisco Chronicle*, August 7, 1996

I think that the aliens, when we contact them at last, will be just like us, and that we will find the universe is full of—human beings! I imagine the plants and animals of distant planets to be much like earthly ones, perhaps sharing the same phyla and orders; ferns, succulents and flowers; vertebrates and invertebrates, fish and mammals. My fantasy universe is an extension of earth, just, perhaps, as the Egyptian afterlife was another Egypt; made of finer stuff no doubt, but still an extrapolation of the life we know.

The first pretenses of children—that they are kings and emperors who command armies and galaxies, are given up as illusions after growing up. But after living a while longer these intimations may again become truth. One again sees the mind at last as the mover of worlds. One again senses the sovereignty and scope of powers from which we are not severed.

If the Modern Age ended with the Holocaust and the bombing of Hiroshima and Nagasaki, the world after these catastrophes could never be seen again as it had been before. The hope of Modernism that a finer, freer and richer future should arrive, that history was a progress of consciousness and knowledge, that humankind was on the march toward a great achievement—all of these ideals have crumbled. Today the entire planet is experiencing the trauma of mass migrations, famine, racial and territorial wars, overcrowding, desperate poverty and disregard of life. Our beautiful earth has been exploited beyond its capacity to sustain us. What can possibly change the course that threatens to destroy the human race and every form of life on earth? Only a complete transformation of consciousness. The ancients knew the world was a globe, but this knowledge did not permeate human consciousness until the commercial voyages to the New World only five hundred years ago. The Liber Chronicum, the first pictorial representations of the inhabitants of the new territories, showed headless bodies with faces on their trunks, bizarre creatures, just as we conceive of extraterrestrials as little green men.

Perhaps a quantum leap will arrive when our lenses and instruments tell us that life is ubiquitous in the universe; that we are everywhere. To have scientific evidence that the planet we inhabit is part of an unending ocean of life and intelligence will spark an evolution of our collective consciousness, replacing our ignorant speculations and propelling us into a new age in which we shall have met the alien, and found that he is us. We shall eventually discover that not only have we been reaching

for the stars, but just as we knew as children, the stars are reaching for us.

Then our understanding of art will deepen also, when we know that its origin is in the universal Mind of us all, the one source of all life and every thing, ever open, clear, unobstructed; forever innocent and unspoiled. Creative, immeasurable, spontaneous Mind, the new principle of energy in the twenty-first century.

> *Oh, if only you would open the door of this house for an instant, you would see that the heart of every existent thing is your intimate friend.*
> —Jalal al-Din Rumi

Godspeed!

SUGGESTED READING LIST

Ancient Wisdom
Venerable Gyatrul Rinpoche (trans. B. Alan Wallace and
 Sangye Khandro)
Snow Lion Publications, Ithaca 1993

Art of Crete and Early Greece
Friedrich Matz
Greystone Press, New York 1962

The Art Spirit
Robert Henri
Harper and Row Publishers, New York 1951

The Awakening of Intelligence
J. Krishnamurti
Avon, New York 1973

Creative Dreaming
Patricia Garfield, Ph.D.
Ballantine Books, New York 1974

Concerning the Spiritual in Art
Wassily Kandinsky (trans. M.T.H. Sadler)
Dover Pulications, New York 1977

Dictionary of Subjects & Symbols in Art
James Hall
Harper & Row, New York 1974

Dictionary of Symbols
J.E. Cirlot (trans. Jack Sage)
Barnes & Noble, New York 1962

Drawing
Daniel M. Mendelowitz
Holt, Rinehart and Winston, Inc., New York 1967

Drawing: A Study Guide
Daniel M. Mendelowitz
Holt, Rinehart and Winston, Inc., New York 1967

Ego and Archetype
Edward Edinger
Shambhala Publications, Boston 1992

The Herder Symbol Dictionary
Boris Matthews
Chiron Publications, 1986

The I Ching
Richard Wilhelm and Cary F. Baynes
Princeton University Press, 1977

In the Way of the Master
Chinese and Japanese Painting and Calligraphy
Bulletin of the Museum of Fine Arts, Houston, Feb. 1981

The Last Flowers of Manet
Robert Gordon and Andrew Forge (trans. Richard Howard)
Abrams Inc., New York 1986

Light and Colour in the Open Air
M. Minnaert
Dover Publications, Inc., New York 1954

Mandala Symbolism
C.G. Jung (trans. R.F.C. Hull)
Princeton University Press, Princeton 1959

Mastery Through Accomplishment
Hazrat Inayat Khan
Omega Press, New Lebanon 1978

The Metaphysical Poets
Helen Gardner, MA, D.Lit
Penguin Books, London 1957

Mudrá
E. Dale Saunders
Pantheon Books, Inc., New York 1960

Mudrá—Manos Symbolicas en Asia y America
Samuel Marti
Litexa, Mexico City 1971

LEONARDO'S INK BOTTLE

The Multiple States of Being
René Guénon (trans. Joscelyn Godwin)
Larson Publications, Inc., Burdett 1984

The Nude
Kenneth Clark
Princeton University Press, Princeton 1972

Penguin Dictionary of Symbols
Jean Chevalier and Alain Gheerbrant (trans. John Buchanan-Brown)
Penguin Books, London 1969

The Sacred and the Profane
Mircea Eliade (trans. Willard R. Trask)
Harcourt, Brace & World, Inc., New York 1959

The Secret Teachings of All Ages
Manly P. Hall
Philosophical Research Society, Inc., Los Angeles 1988

Secrets of the Skeleton
L.E.C. Mees
Anthroposophic Press, Spring Valley 1984

The Selected Poetry of Rainer Maria Rilke
Edited and translated by Stephen Mitchell
Vintage International, New York 1989

Songs of Innocence and of Experience
William Blake
Orion Press, New York 1967

The Spirit of the Forms
Elie Faure (trans. Walter Pach)
Garden City Publishing Co., Garden City 1937

Spiritual Dimensions of Psychology
Hazrat Inayat Khan
Omega Press, New Lebanon 1981

The Sufi Path of Love: The Spiritual Teachings of Rumi
William C. Chittick
State University of New York Press, Albany 1983

SUGGESTED READING LIST

The Supreme Doctrine
Hubert Benoit
Routledge and Kegan Paul, London 1955

The Tao of Symbols
James N. Powell
Quill, New York 1982

To Myself; Notes on Life, Art and Artists
Odilon Redon (trans. Mira Jacob and Jeanne L. Wasserman)
George Braziller Inc., New York 1986

Thomas Traherne: Selected Poems and Prose
Alan Bradford, Editor
Penguin Books, London 1991

The Uninhibited Brush: Japanese Art in the Shijo Style
J. Hillier
Hugh M. Moss Publishing Ltd., London 1974

The Unknown Craftsman
Soetsu Yanagai
Kodansha International, Tokyo 1972

Vermeer
Lawrence Gowing
Harper and Row, New York 1952

*Visionary & Dreamer: Two Poetic Painters, Samuel Palmer
 and Edward Burne-Jones*
David Cecil
Princeton University Press, Princeton 1969